COPPELL
TEXAS
· A HISTORY ·

JEAN MURPH AND LOU DUGGAN

THE
History
PRESS

Published by The History Press
Charleston, SC
www.historypress.net

First published 2016

Manufactured in the United States

ISBN 978.1.46713.661.7

Library of Congress Control Number: 2016943511

Notice: The information in this book is true and complete to the best of our knowledge. It is offered without guarantee on the part of the authors or The History Press. The authors and The History Press disclaim all liability in connection with the use of this book.

CONTENTS

Preface 5

1. Waterways Provide for Coppell's Unique Terrain 7
2. Native Americans, Coppell's First Inhabitants 11
3. Sam Houston's Visit and a Peace Treaty 15
4. James Parrish Received the First Land Grant 19
5. Coppell Was a Farming Community 23
6. Families Were the Foundation 27
7. Coppell Had Grand Homes 55
8. Youngsters Were Served by Three Area Schools 59
9. Early Churches Bound the Community 71
10. Four Historic Cemeteries Trace Residents' Roots 79
11. Railroad, Roads Put Settlement on the Map 85
12. Hard Times: The 1920s 91
13. The Great Depression: The 1930s 95
14. Marked by Loss and Sacrifice: The 1940s 109
15. Destiny Calls: The 1950s 121
16. The Turbulent 1960s 133
17. A City Evolves: The 1970s 147
18. City Staff Grows 163

Coppell Timeline 171
Coppell's Mayors 173
Acknowledgments 175
About the Authors 176

PREFACE

It is with pleasure that the authors have gathered tales and images that encapsulate the early history of a small Texas community that saw, among many things, Indians, Sam Houston, the advent of the railroad and an extensive WPA park project. Coppell began as a rural farming settlement and has become a city influenced by corporate development, light industry and a nearby major airport.

But always undergirding the town has been a deep devotion to family and pride in the community by its residents, making the authors' task more meaningful and fulfilling.

The history of Coppell extends back as many as eight generations, and it is easy to confuse generations, buildings and homes that have experienced multiple owners. Therefore, we have relied on the historical record and the firsthand memories of early Coppell residents.

We are grateful for the contributions of many citizens and in particular the Coppell History Society for access to its photograph collection. We hope you enjoy the history of a small Texas town.

All of the photographs in this volume are from the collections and cameras of the authors.

1

WATERWAYS PROVIDE FOR COPPELL'S UNIQUE TERRAIN

If one thing makes Coppell unique in the sprawling Dallas metroplex, it is that the town is virtually surrounded by creeks and bodies of water and bordered by major highways, creating a self-contained enclave. Today, the town is bordered by Lewisville to the north, Irving to the south, Carrollton to the east and Grapevine to the west.

Six bodies of water flow into the area. As described by state archaeological stewards and Coppell residents Paul and Jan Lorrain, who explored the area, northwest Dallas County is drained by Denton Creek on the city's north side, flowing into the Elm Fork of the Trinity River, which forms the city's far eastern boundary. Two smaller creeks also drain the area: Cottonwood Branch, which flows into Denton Creek from the south, and Baker's Branch, which enters the creek from the north. Grapevine Creek, two miles south of Denton Creek, and Timber Creek, an equal distance to the north, also drain southeast into the Elm Fork of the Trinity.

The creeks and river in Coppell have provided physical, spiritual and recreational nourishment for early travelers, including Native Americans and eventual settlers. They provided water for drinking, cooking, washing, watering crops and fishing. Travelers and settlers throughout history have selected sites with at least one source of water, an example being Native Americans and later General Sam Houston, who camped along Grapevine Creek in 1843 while waiting to meet with Indian tribes. Baptisms were regularly held in the Trinity River, along with swimming, picnics beside the river and other recreational activities, including youth skating on the frozen creeks.

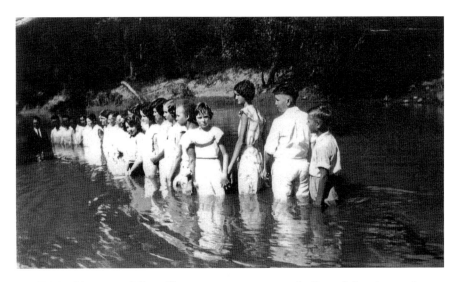

The Trinity River, one of Coppell's many waterways, was a site for early baptisms and social events.

Early residents referred to the hills due east of North Lake and in Valley Ranch, on the city's southeast side, as Caddo Mounds. While Native Americans likely camped in the area, and the Caddo Indians were among tribes meeting in the area with Sam Houston in 1843, the hills at North Lake and Valley Ranch are thought by Texas state archaeologists to be natural elevations and not typical early burial or ceremonial Caddo Mounds.

The Coppell area experienced a one-hundred-year flood in the early 1900s. The *Dallas Morning News* wrote, "The Trinity flood crested at an early hour yesterday morning [May 15, 1905] and began to recede and the fall was rapid throughout the day. By nightfall, there was a considerable depth of water over the West Dallas pike and Zang Boulevard." County commissioners posted guards at various locations to "keep anyone from attempting to ford the depths." No loss of life was reported, but "some loss of cattle and livestock and some destruction to wild animals" occurred. Four culverts were lost near Coppell. Parkway Boulevard, the current site of Town Center, and Brown Park were under water, along with floodplain land to the east. Lake Grapevine was later established to aid with flood control.

One natural phenomenon met the fate of development, however. Turkey Knob Hill, a natural hill on the west side of North Denton Tap Road, across from today's Town Center, was razed in the 1990s with the permission of the Coppell City Council, and the dirt was used for roads

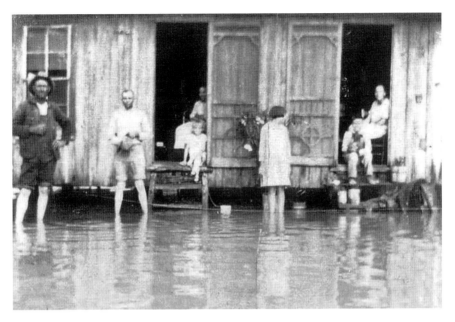

The town experienced a one-hundred-year flood in early 1900 that left residents in ankle-deep water.

and a housing development. Huntington Ridge subdivision sits where Turkey Knob once stood.

Today, Coppell residents preserve and enjoy the creeks primarily for recreational activities. Efforts have been made by the City of Coppell to preserve the natural setting of Grapevine Springs Park, one of the predominant historical sites in the metroplex, and to develop biking, walking and jogging paths along the creeks to connect the city. In addition, thousands of acres have been set aside for passive parks and nature preserves, including Coppell Nature Park on the west side.

2

Native Americans, Coppell's First Inhabitants

Remains from 2000 BC Uncovered

Long before settlers arrived in the area that is now Coppell, Native American tribes inhabited the plains and were drawn to the water that bubbled from the natural springs that formed Grapevine Creek. Artifacts dating back to 1500 BC have been found along the banks of Denton and Grapevine Creeks, on Coppell's north and south sides. Both creeks feed into the Elm Fork of the Trinity River, a river that also attracted Indians. Old-timers report finding arrowheads along the banks of Grapevine Creek and the Trinity River, but those findings remain in private collections.

Paul and Jan Lorrain conducted numerous searches along the creeks and documented their findings in archaeological journals. In a September 2001 issue of the *Record*, they wrote, "The 1980s in northwest Dallas County saw rapid change, with roads built, streams diverted, and borrow pits excavated. Archaeological sites were frequently exposed by these land modifications," especially along Denton Creek, from Grapevine Dam in Tarrant County to the Elm Fork of the Trinity in Dallas County. Ultimately, eleven sites were recorded along that section of creek.

"Evidence of prehistoric human occupation along lower Denton Creek has been accumulating since the 1940s, when artifacts were found along the creek near Denton Tap Road and a human skeleton was unearthed in a nearby gravel pit," said the Lorrains. "The artifacts date back to the Late Archaic Period, 2000 BC to AD 700, and include points (early arrowheads),

The Ledbetter farm, depicted west of the Elm Fork of the Trinity River, provided archaeological evidence that Native Americans were the area's first inhabitants.

drills, manos (grinding stones) and preforms. Cooking hearths were also a common feature at the sites, but their small size indicated they were not used for an extended period. Bones of deer, fish, turtle and probably bird were found at hearth sites. The absence of human remains may indicate the area was used temporarily."

Regarding more recent exploration along Grapevine Creek, in early 1992, Dallas County, which leases Grapevine Springs to Coppell, asked the Dallas Archeological Society to test for remains prior to restoration of the park. The Lorrains described the prospect of extensive findings as "dim," due to treasure hunters through the years who removed artifacts. Local residents had found military musket balls and metal buttons in addition to Indian artifacts.

During the search, a total of eighty-nine artifacts was recovered from the site, primarily bottle glass, nails and ceramics, most of them dating to the twentieth century. A significant find was a "pearlware, whiteware rim sherd [pottery], decorated with incised shell edge, painted green, with a cockled rim. Based on the type of paste, rim and decoration, the sherd can be dated to the 1830s," they wrote. Wire nails and .22-caliber rimfire cartridge with a

"U" headstamp were among metal items found. Prehistoric items consisted of flakes and shatter, a small arrow preform and a battered core, found primarily in an area just outside the park.

Native American tribes contributed to subsequent Coppell history, most notably with their arrival in 1843 at Grapevine Springs to meet with Sam Houston, president of the Republic of Texas.

Animal Inhabitants Date Back Millions of Years

Early explorers reported a variety of larger animal habitation, including antelope, bear, buffalo, panther, elk, wolves and javelina in the *Record*, the Dallas County archaeological journal. According to Dave Garrett, a Coppell history teacher and researcher, the last buffalo in Dallas County was reportedly killed at Grapevine Springs. He also mentioned reports of a bear breaking up a religious revival at the creek.

One of Coppell's earliest inhabitants appeared ninety million years ago. In 1992, an eight-foot shark fossil was discovered on the city's west side, according to Kitty Cox in the *Citizens' Advocate* newspaper. The entire block of rock and earth containing the fossil was removed from the site and taken to the Dallas Museum of Natural History, where the remains were studied and dated. Mobil Oil was among the groups that chemically tested the volcanic rock in which the fossil was found. The "scapanorynchus" or "goblin" shark dates to the end of the Age of Dinosaurs, when the Gulf of Mexico covered the area, according to Charles Finsley, curator of the Dallas Museum in 1992. Several shark fossils had been found in Kansas, he said, but this particular type had only been found in Lebanon.

Since that time, during archaeological searches, ammonites and other ancient natural relics have been discovered in creek beds and the bed of North Lake, when it was drained in 2014. Local paleontologist David Goodner has uncovered and preserved many ancient remains found in Coppell creek beds, including a prehistoric bison bone and deer teeth.

3

SAM HOUSTON'S VISIT AND A PEACE TREATY

Sam Houston, as president of the Republic of Texas, was instrumental in putting the Coppell area on the early Texas historical map. The purpose of his visit was to seek peace with Indian tribes. Houston biographer James Haley, in a 1990 speech at Coppell's Grapevine Springs Park, said many U.S. places mark the site of a battle, but very few mark the site of peace.

Sam Houston, who had lived with the Indians in earlier periods of his life, wanted to open the northern portion of Texas to permanent settlement for Anglos and Native Americans and end fighting. He invited ten tribes—Delaware, Chickasaw, Waco, Tiwocano, Keachie, Caddo, Anadahkah, Ionie, Biloxi and Cherokee—to enter into a peace treaty at Bird's Fort on the Trinity River in August 1843. Earlier, General Edward H. Tarrant had given Jonathan Bird orders to establish a military post at a site in present-day Arlington that became known as Bird's Fort.

In late July 1843, Sam Houston left the Texas capital, Washington on the Brazos, and traveled north with an expeditionary party, including John Neely Bryan, G.W. Terrell, Thomas Keenan, an individual called by the name Sanchez, Edward Parkinson and James Beeman. Houston and his men journeyed through Crockett, Kingsborro, Dallas, Cedar Springs and Peters Colony (Carrollton) to "Grape Vine Springs," reportedly traveling to Bird's Fort along the way.

The group stopped to camp for a few days at what is now Grapevine Springs Park in Coppell, where they prepared to negotiate the treaty. The site, on Park Road at West Bethel, is now a county park leased to the City

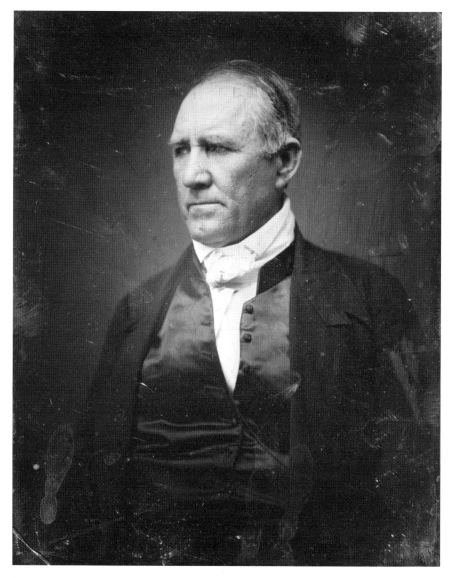

President of the Republic of Texas and future governor Sam Houston came to the Coppell area in search of a peace treaty with Native Americans.

of Coppell. Edward Parkinson, a member of Houston's party, described the camp in his journal, which is preserved at the Dallas Public Library: "From Bird's Fort on the west to Grape Vine Springs on the Elm Fork, about six miles above us, we turned off to the right and soon reached the camp, where we spent some five or six days rather monotonous, only relieved by finding a

bee tree or killing beeve [beef], and speculation on the delay of the Indians incoming to the Treaty, which excessively annoyed Sam Houston, who swore vengeance against his commissioners, imagining the delay caused by them, and he finally determined to return to Washington by way of the falls of the Brasos [sic]."

With other business pending, Houston finally returned to Washington on the Brazos, leaving Generals Terrell and Tarrant to sign the peace treaty at Bird's Fort on September 29, 1843. The treaty was formally signed by Houston in 1844. Although this was not the first treaty that had been signed in the area, it was quite possibly the most important, allowing habitation of the upper Trinity River.

In *The Indian Exodus*, Kenneth Neighbors wrote that, in accordance with the treaty, "neither side was to cross an agreed upon dividing line; courts were to try whites who killed an Indian in peacetime; an Indian who killed a white person was to suffer death. The treaty was very important and was used to keep recalcitrant Indians and unprincipled white men in line."

Only authorized persons could cross the forbidden line: blacksmiths, teachers and licensed tradesmen. On the eastern side of the border was the white man's farmland, and on the western side was the red man's buffalo-hunting territory. This line is essentially where the East disappeared and the West began.

As described in Julia Garrett's *Fort Worth, a Frontier Triumph*, Houston displayed "Indian pomp, fidelity of Houston's youth…easily summoned to dramatize his action. He clothed his giant frame in a purple velvet suit embossed with embroideries of fox heads. An extraordinary bowie knife of giant size, conspicuously thrust in his belt…a well folded Indian blanket thrown in debonair manner over his shoulder proclaimed, in brilliant hues, his brotherhood with the red man."

According to Garrett, Houston said, "We are willing to make a line with you, beyond which our people will not hunt. Then in red man's land beyond the treaty line unmolested by white men, the hunter can kill the buffaloes and the squaws can make corn." Writes Garrett, "A seal of the Republic mounted upon white, blue and green ribbons makes the signature of President Houston, Indian Commissioners Terrell and Tarrant, and the marks of the unlettered chiefs an authentic and binding law. In fading ink, one can read the twenty articles which opened the wilderness about the forks of the Trinity." The twenty articles detailed rules for both whites and reds.

A treaty line was established, along which a series of trading houses were built where Indians could bring hides and pelts to barter for needed goods.

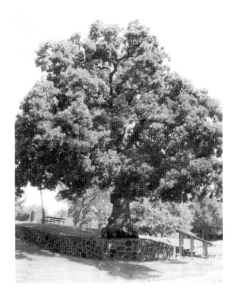

Houston Oak. Sam Houston camped at Grapevine Springs for several days under what was described as a large oak, waiting to meet with Indian tribes.

White persons could not go beyond the line without special permission or trade license. The treaty also provided for communication, friendship and aid between whites and natives, according to Garrett.

The Texas Congress ratified the treaty on January 31, 1844, and it was signed three days later by Houston. Several months later, twenty Indian chiefs and their parties gathered at the capital and were given gifts by Houston. Said Garrett, "This 1843 treaty was to be the means by which the lands about the upper Trinity emerged from wilderness to habitation and became the pattern for future treaties. The treaty of 1843 provided the future city of Fort Worth the slogan, 'Where the West Begins.'" The treaty resides in the archives of the State Library of Texas. Today, Sam Houston's path is recorded with landmarks, including a Sam Houston Trail Marker in Valley Ranch at Ranchview Drive and Ranch Trail.

In October 2005, a Texas State Historical Marker was dedicated in Grapevine Springs Park commemorating the site of the Sam Houston camp, the springs used by the Indians and settlers and a later WPA park-building project. In 2012, an oak tree measured to be over three hundred years old was named a "Famous Tree of Texas," with the title Houston Campsite Oak, and commemorated with a ceremony and plaque. The oak appears in the 2015 edition of the book *Famous Trees of Texas*.

Grapevine Springs Park has long been a central gathering spot for Coppell residents to walk to the creek and through the woods, hold picnics and events and enjoy play and sports. Earlier residents even developed a baseball field on the west side of the park.

Today, historical preservationists point to Grapevine Springs Park as one of the primary historical sites in Dallas County, due to the visit of Sam Houston and later work of the WPA.

4

James Parrish Received the First Land Grant

Early Coppell historians record that James Parrish traveled to Texas in 1848 and, during that year, received a 640-acre section of land in the Coppell area, establishing him as the first Coppell landowner. The Dallas County Records office holds the original land grant from the State of Texas to Parrish, signed in 1859 by Texas governor J.R. Runnells and granted from the Texas Land Office.

Parrish, who came from Indiana with his brother Henry, developed the tract as farmland. According to early records, the land extended from what is today East Belt Line on the south to Sandy Lake Road on the north, Moore Road on the west to MacArthur Boulevard on the east, an area that today encompasses thousands of homes.

In addition to the Parrish brothers, other early settlers in the area were Josiah Record, James Howell of Missouri and Washington C. Bullock of Illinois, all of whom arrived before the Civil War, according to the writings of William T. Cozby, a descendant of Howell and Bullock. Cozby wrote that two homes were built by Parrish on land located on Moore Road, where the community of Bethel started. Bethel eventually had a cemetery, church, school and other homes. The church and school were located at the southwest corner of Bethel School and Moore Roads. A number of early settlers are buried in Bethel Cemetery, which has a Texas State Historical Marker.

Josiah Record also lived in the Bethel community. James Parrish married one of Record's daughters, Eliza Jane, but died before having children.

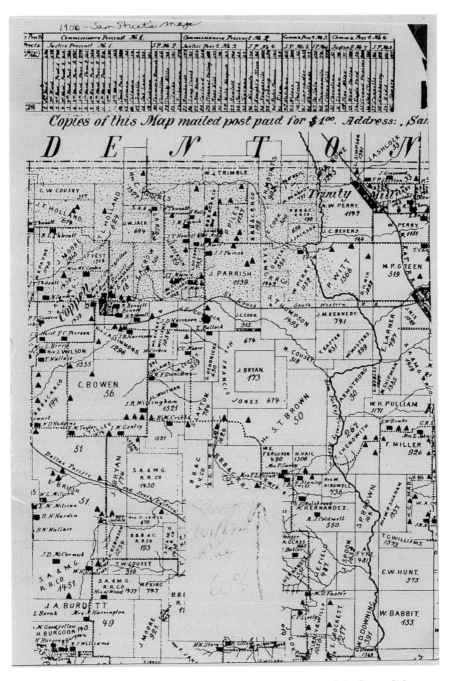

James Parrish received the first 640-acre land grant, which was part of the Peters Colony.

Eliza married his brother, Henry, and they had a large family, with many descendants still living in Coppell. Henry and Eliza Record Parrish were grandparents of Mrs. E.W. Thweatt, connecting the Parrish family with another large Coppell-area landowner, the Thweatt family. In Coppell's early days, the Thweatt family owned a large portion of the land on the west side of Denton Tap Road, west to State Highway 121, from Sandy Lake Road on the south to Denton Creek on the north. Thweatt land south of this tract, across from Coppell's current post office, was purchased at a later time from the Bullock family. On the Bullock land, the first reported brick house in Dallas County was built in 1865, later torn down by the Thweatt family. A frame home was then constructed.

Eva Belle Thompson Parrish, who married Joe Parrish, a Parrish descendant, wrote that Coppell was

> known as a farming community. The main crops were corn, cotton, wheat, oats and Sudan grass. No Bermuda or Johnson grass were allowed on any farm until the latter 1930s. A farmer was considered lazy and unworthy of the name if any weed, Bermuda or Johnson grass grew on his land. I can very well remember our neighbor, farmer Walter Thweatt, going around the boundaries of his farm once a week with a little canvas bag slung over his shoulder and a small "grubbing-hoe" in his hand, checking for and digging up any stray plants of Johnson and Bermuda grass.

Thompson's father came to Coppell in 1895 from Alabama, settling on the Willingham farm, due south of Coppell, and working for Willingham until 1906, at which time he bought twenty-five acres of heavily wooded land northeast of Coppell. According to Thompson, her father bought the land for one dollar an acre, cleared the oak and hackberry trees away, built his own five-room farmhouse, set out a two-acre orchard, built a log barn from timber cut from his land, dug the stumps and put into cultivation the land he cleared. Today this same land "is selling for $10,000 to $20,000 an acre," said Thompson.

A Parrish family descendant, Vert Parrish, recalled how he had served as his father's eyes. His father, another resident with the name Joe Parrish, was blind, "stone blind, for fifty-one years of his life," said Parrish. "I was pretty well employed, went with my daddy everywhere, drove the wagon. I've seen some hard times. Like when cotton sold for five dollars a bale, five cents a pound. I've seen wheat sell for two bits a bushel." Parrish spent many of his eighty-five years helping his father farm land in Coppell and Roanoke.

He was born in 1895 in Coppell on the east side of town, established by his great-uncle James Parrish, as part of the original land grant. Parrish remembered that the land was a territory of Spain, with the grant issued in 1832, before Peter's Colony was established in 1840. Vert Parrish attended Bethel School.

"There wasn't very much [in Coppell] when I grew up. More [back] then, than now," he said. Young Parrish went to work for the Sidney Webb Gin Company in Coppell, which owned ninety-six cotton gins in Texas and Oklahoma. Parrish ran the press. His mother died in 1922, when he was twenty-seven years old. After his father died (he was run over on a highway), Vert Parrish sold their farm and bought the old W.O. Cooper place on Bethel Road, near Denton Tap Road. He then went to work for Dallas County, doing bridge work.

Referring to his wife, Allie, Vert Parrish said, "I knowed her all my life. Her dad, R.T. Moore, had 240 acres down east of Coppell, where they're building all those brick homes [Willow Wood subdivision]." Allie and Vert were married in 1939 and had five children: Janie Ruth, Glenn, Henry, Howard and Almeda. Today, Moore Road is a significant north–south Coppell thoroughfare.

Early Spanish land grants in the Coppell area created large farms, which were often worked by tenant farmers.

Coppell Was a Farming Community

The Coppell area began as a farming settlement, benefitting from water at numerous creeks. Farmers supplied crops, food and goods to residents, supporting the local economy. Families had as many as thirteen children, many of whom led a carefree country life but also pitched in to pick cotton and work on the farm.

Tenant farmers also lived and worked for large landowners, giving one-fourth of their corn and one-third of the cotton to the landowner. Cotton was taken to the gin in wagons, and "ladies made the cotton pickers' sacks from heavy white duck material—seven yards for adults and four yards for children," one unidentified writer recorded. "A child's first sack was made from a 48-pound flour sack."

Also described in the old downtown area along today's West Bethel and Coppell Roads were two garages, a "filling station," an icehouse, a barbershop and a bank.

The writer chronicled the sad story of Minnie McGee, who ran the post office and drugstore in old downtown, which "sold ice cream and the old soda fountain [pressure] blew her husband's head off." Other old-timers verified the incident. Then, "Peter Miles fell in love with Minnie. She would not marry him, so he sped around the corner there and killed himself." Allegedly, Minnie later became insane.

Another landmark in old downtown Coppell was a two-story brick building. Myrtle Hurst, a widow with a daughter, Iris, ran a grocery store on the first floor. Woodsmen of the World met on the top floor. New members

of the lodge were initiated by "being taken to see the skeleton." The writer does not elaborate. Another old-timer called the upper rooms the Odd Fellows Lodge. In later years, Aunt Nora Stringfellow lived in the upper rooms of the building where the lodge met. She had a kissing parrot.

Two cotton gins were also old downtown businesses, sites where gambling reportedly sometimes occurred. The unidentified writer reported that Aunt Nora Stringfellow commented about the gamblers, "Humph. Coppell should have been named 'hot hell.'" She reveals details about an affair between two prominent Coppell residents that resulted in a black eye for the woman, "delivered to her by the betrayed wife."

While the advent of the railroad and local depot stand as pivotal points in Coppell's early development and helped provide Coppell its name, the post office and mail delivery played a significant role for another reason: it later made the name change necessary. The post office began in 1887 and was first housed in Minnie McGee's drugstore downtown. Townsfolk would come by to pick up their mail. Minnie was the first postmaster, recalled postal carrier Ira Coats years later. In its archives, the Coppell public library has a framed postcard with the Gibbs postmark from a family member describing the farm crop that year. A later post office was established in the W.O. Harrison grocery store on West Bethel Road.

The Coppell area was first called Grapevine Springs Prairie and later Gibbs, named after nearby landowner and Texas lieutenant governor Barnett Gibbs. Because of the railroad and depot, Gibbs was sometimes called "Gibbs Station."

POST OFFICE AND RAILROAD LEAD TO TOWN'S NAME CHANGE

The change of the town's name to Coppell was long a mystery to local historians. But old-timers recorded that the post office was informed that an East Texas post office or town already had the name Gibbs, and confusion with mail would result. Notification to the post office occurred around the time that the railroad came to town, and residents decided to name the post office after a railroad executive, George A. Coppell, who helped save the railroad from bankruptcy.

The name Coppell appeared in a March 3, 1886 *Dallas Morning News* article that described the financial failure of the Texas and St. Louis Railroad.

According to the article, funds were insufficient in 1886 to resuscitate the railroad, and a New York trust company was named trustee in the mortgage securing the bonds. Schemes were designed to reorganize the railroad and a receiver appointed. Several offers were scuttled, with the asking price rising to $7 million. Finally, a purchasing committee was formed, and among the five members was George Coppell. Others were William Mertens, M. Gernsheim, Lewis Wolf and J.W. Paramore. The purchase was made for the benefit of bondholders, according to the article, and a reorganization plan was initiated. One of the bondholders was the estate of an individual named Delmonico, at the time a New York caterer, whose name later became associated with a well-known New York restaurant. Old railroad stock was declared worthless after reorganization.

In 1890, the town became Coppell, and in 1892 the post office name changed to Coppell.

More recently, local historian Pete Wilson did extensive research on George Coppell, finding a photograph of him and other documentation preserved by the Coppell Historical Society.

Clayta Harwell later described helping her aunt Myrtle Hurst as a railroad agent. Hurst pulled a red wagon to bring the mail from the train to town. Harwell later took over the job. Hurst's predecessor at the railroad depot was Oscar Cooper, who was the last full-time railroad agent in Coppell.

Coppell's first mail route was established in 1904, according to Ira Coates. In 1922, Coppell's mail carrier requested a transfer to Dallas and asked Coates, a Dallas carrier, if he would like to trade routes. He readily agreed.

"I had 50 miles and 550 boxes in Dallas," said Coates. "That fellow [in Coppell] had a 27-mile route and 100 boxes. Of course I came." But that was not the only reason he came. He had spent time in Coppell farming for "Uncle" Charlie Moore and had met his daughter, whom he later married. It was on his Dallas route that he met his future brother-in-law, Tom Moore, an auto technician at the store where Coates purchased his first Ford. In 1922, Coates and his wife moved to Coppell, and he served as carrier for forty years. He remembered when "homes were scarce and spread out. Horses and mules did all the farming then."

He first delivered mail in his Model T Ford, for which he paid $565. The mail was still delivered to the drugstore in those days. He remembered Coppell having a gin, train depot, Gentry's filling station, Stringfellow Grocery Store, Harrison Grocery, Minnie McGee's Drugstore, Myrtle Hurst's store and more.

The post office was later housed in a building that still exists at 446 West Bethel in old downtown, a frame building later occupied by realtors; two newspapers, the *Coppell Star* and the *Citizens' Advocate*; Dolly's Café; and several other businesses and stores. Coppell's earliest-known and shortest-lived newspaper was called the *Informer*. Domino games were held on the sidewalk in front of the post office building and later in a small building across the street.

Several post offices succeeded the frame building, including a building on South Coppell Road, a retail front in the Braewood Center and the current building on South Denton Tap Road. A bulk mail center on West Bethel Road also made Coppell its home in the late 1980s.

Because the town had no fire department, fires sometimes resulted in total devastation. In December 1903, a cotton gin fire at the farm of T.J. Harrison "was soon extinguished with a loss not exceeding $2,000," reported the *Dallas Morning News*. In October 1904, the newspaper reported that W.S. Sanders's barn burned with one hundred bales of hay, one hundred bushels of corn and some oats. The barn was not covered by insurance, the article stated. The G.T. Bullock barn burned and the dwelling of G.C. Corbin was destroyed because of a defective flue, recorded the newspaper.

Crime in Coppell was also reported in the *Dallas Morning News*. In 1899, a Dallas County Grand Jury investigated the killing of James Bennett, a Coppell farmer. J.P. Cozby and Frank Lusk, described as laborers, were charged with murder and arraigned. No details were provided about a trial. A duel on Coppell Road was also reported. In 1917, John Cribbs was charged with murder of a railroad foreman in a dispute. The foreman was struck with a railroad spike.

6

FAMILIES WERE THE FOUNDATION

Coppell began on the strength of the family—building, working, worshipping and playing together. The heads of the earliest families were James and Henry Parrish (1853); Josiah Record, who married a Parrish, (around 1853); James P. Howell (1859); Washington C. Bullock (1866); Joseph Thweatt (1868); J.B.K., W.O. and T.J. Harrison (1873); Adam "Ad" Crow (1874); Charles Moore (1876); and Alexander and Milford Gentry (1878). Frequently, marriages occurred between these families. Many subsequent Coppell family names appeared after this time and through marriage.

Among additional early family names were McCord, Hodges, Pirkle, Holt, Willingham, Standifer, Cozby, Brown, Sanders, Witt, Sisk, Bryant, Dickerson, Myers, McDonald, Russell, Woods, Stringfellow, Thomas, Thompson, Moody, Cunningham, Denton, Miles, McGee, Powell, Whiteside, Harwell, Plumlee, Simmons, Hurst, Cummings, Sasse, Neal, Shelton, Patrick, Etheridge, Drake, Hulen, Cribbs, Ott, Van Tress, Fields, Arnett, Kellen, Banker, Klingbell, Tucker, Wulfgen and Coates. In the Bethel community, on the east side of town, were families named Ledbetter, Evans, Weldon, Allen, Noble, Polk, McAnally, Ottinger, Wright, Prater, Houston, Stout, Waters, Pugh, George, Gordon, Silk, Aught, Asch, Whatley, Keener, Duwe and Wheeler.

While much is known about some of the families, less has been recorded about others. Nevertheless, family histories and adventures help tell the Coppell story.

Children in the early 1900s.

Bullock and Howell Families Joined by Marriage

Washington C. Bullock and James Penson Howell, who came from Illinois and Missouri before the Civil War, were prominent citizens, but little has been recorded about them. In 1865, Bullock built his home on the northwest corner of the intersection of Denton Tap and Bethel School Roads, according to grandson William T. Cozby, who added that the structure was said to be the first brick house in Dallas County.

James Penson Howell and his wife, Melinda Pemberton, built a home on what is today Sandy Lake Road's intersection with Lodge Road, and they had a son, Burrell Bertram, who was a charter member of the Methodist church and served in the Civil War. He married Susan Bullock, joining the two early families.

The Burrell Howells built a two-story frame house on large acreage north of today's Pinkerton Elementary and north of the railroad track near Grapevine Springs Park. Howell kept his eggs, milk and butter in the cool water of the springs, according to his granddaughter Mary Evelyn Cozby. Each Sunday, as he walked to the Methodist church in town, he would leave a dressed chicken in a minnow bucket in the spring to keep it cool and pick it up for Sunday dinner on his way home from church. A daughter married Dr. John Cozby, who was the second doctor in town, preceded by Dr. Camp. Cozby also owned a drugstore, run by his brother James Robert. After John's death, James Robert continued to run the store until the family moved to a farm on East Belt Line Road, which "ran back to Grapevine Branch," said Mobley, the place where she, Bill and other Cozby siblings grew up.

James Trimble Cozby, father of James and John Cozby, built a home near the drugstore that faced west on South Coppell Road. The home was later purchased by Claude Plumlee.

Thweatts Were Large Landowners

The Thweatt family owned a large tract of land on the west side of Coppell. When combined through marriage with the Parrish family, which received the first land grant on the east side of town, the families became perhaps Coppell's largest landowners. The Thweatt family name, which

can be traced back to England, first appeared in the Commonwealth of Virginia in a 1670 land grant. The name was then spelled Thweat. Thomas Branch Thweatt came from England around 1815 and settled near relatives in Virginia. A son, William Archer Thweatt, born in England and the father of eleven children from his first marriage and five from his second marriage after his first wife died, came to Texas in his old age and died near Grapevine at the home of Joseph Thomas Thweatt.

Joseph Thomas Thweatt, born in 1836, came to Texas from Mississippi and settled at Gibbs (Coppell) with his bride in 1868. Joseph's five sons were Robert Whitley Thweatt, Richard Lee Thweatt, William King Thweatt, Joseph Walter Thweatt and Jefferson Davis Thweatt. According to great-grandson J.C. Thweatt and other Coppell old-timers, Joseph acquired a large section of land encompassing land on the northwest side of Coppell, bordered today by Denton Tap Road, State Highway 121, Sandy Lake Road and Denton Creek. Joseph Thweatt passed the land to his sons. One of them, Joseph Walter Thweatt, J.C.'s grandfather, eventually acquired all of the land from his brothers and farmed the land, providing homes and jobs for tenant farmers.

In 1904, Joseph Walter Thweatt bought 170 additional acres on the northwest corner of Bethel School and Denton Tap Road, land to which J.C. eventually moved and lived until his death. The Washington Bullock family had formerly owned the land, where in 1865, the first brick home in Dallas County was built.

In 1914, the brick house was torn down, and Walter Thweatt built a frame house on the site. The house served as the family home until it burned many years later, and Mrs. Thweatt moved to Farmers Branch. The property was the site of the old windmill that J.C. Thweatt gave to the city in 2002 as an old downtown anchor and landmark, signifying the importance of farming in Coppell's past. Today, the windmill sits in Heritage Park next to the Kirkland House.

An unidentified old-timer wrote that the Thweatt family was on the cutting edge of new technology. They bought a fancy surrey with fringe on top, and the horses had red silk tassels. The Thweatts later replaced the surrey with one of Coppell's first cars, a Ford with silver flower vases on each side of the back seat, containing red roses. The writer recalls going "up to Jeff Thweatt's big house" to hear one of the first Edison phonographs. "Jeff owned the biggest wheat threshing machine around, called Old Minnie," the writer recalled, and for two summers, she and her

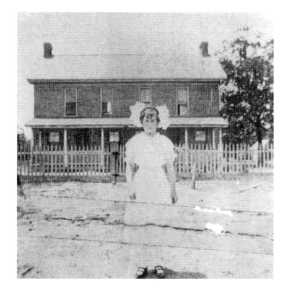

Left: Ruby Thweatt posing at home, said to be the first brick house in Dallas County. The house was built by the Bullock family in 1865.

Below: The five Thweatt brothers.

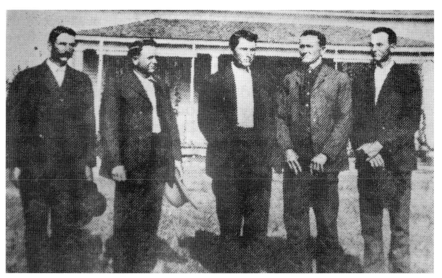

grandmother went with the threshing crew from farm to farm and slept and cooked in the cook shack.

During his younger years, J.C., who lived with his family in Oak Cliff, spent many days in Coppell, hunting with his father and helping his grandfather with farming chores. He also recalled many days climbing on the windmill. Thweatt's father, Elgie, worked in the district clerk's office in the old county

courthouse in downtown Dallas, called Old Red today. The family moved to University Park when J.C. was thirteen, and he graduated from Highland Park High School. Thweatt worked for an electrical company and helped his father with a publication, the *Pink Sheet*, which provided information on new car sales for auto finance and insurance companies. He married Jean, who worked at UTD, and they lived on Preston Road for years. Thweatt developed a mobile home park on the Denton Tap Road property, and they moved to Coppell in 1965. His wife died in 1972, and Thweatt closed the mobile home park. His mother lived in a trailer in the park until her death.

For many years, the road along the Thweatt property was named Thweatt Road (West Sandy Lake today). In recent years, Thweatt Road was changed by the City of Coppell to be consistent with the rest of Sandy Lake Road, and instead, a small park nearby was named Thweatt Park. According to several residents, when J.C. heard about the name change, he said he did not care, and he went out and retrieved the old Thweatt Road sign. His family later donated the sign to the Coppell Historical Society along with other memorabilia.

THE HARRISON FAMILY GENEALOGY IS INTERTWINED

Clifton D. Harrison and Lorene Pirkle were among family members who shared historical data about the Harrison family. Lorene Pirkle, ninety years old on December 10, 2005, published a family genealogy, evidencing that the genealogical path of Coppell's founding families is intertwined. Pirkle's mother was a Harrison, descending from Thomas Jefferson Harrison, brother of William O. and Jonathan B. Harrison. Her father, E.W., was a Gentry. Her grandmother was a Sanders. By marriage, Pirkle was kin to the Plumlee, Parr, Ratliff, Corbin and Whiteside families, to name a few. She was also kin to Barbara Lee and Pat Lambert, among family members who still live in the Coppell area.

One of the early Harrison brothers, W.O. Harrison, applied for a post office for Gibbs in 1887, which was soon approved, and Harrison was appointed the first postmaster.

Grandson Clifton Harrison chronicled the lineage of Jonathan B.L. Harrison, the third child of Jonathan Tyler and Jemima Delina Harrison. At the age of eighteen, in 1870, he came to Texas, buying land in Dallas County. His farm, consisting of over 162 acres, was located on Grapevine

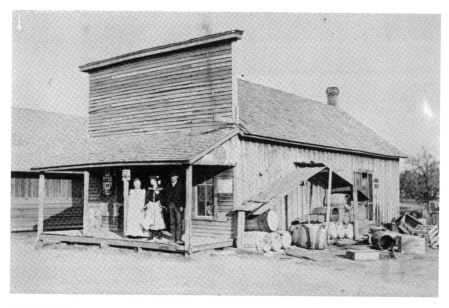

The W.O. Harrison general store also housed the post office, signified by a small sign on the top right side of building.

Branch near Grapevine Springs. According to Clifton Harrison, "He kept the land in a fine state of cultivation, raising an abundance of cotton, corn and small grain."

With his brothers W.O. and T.J. (Thomas Jefferson), who had by then also come to Texas, J.B. was in the mercantile business in Gibbs, doing business under the name of Harrison and Company. He chose what was later called Harrison Hill as the location for his home. The land overlooked Grapevine Branch, one and a half miles southeast of Coppell, along today's Southwestern Boulevard near South Belt Line. J.B. Harrison was married in Cass County, Texas, December 3, 1873, to Nancy Leora Grubbs, a native of Anderson District, South Carolina. They had eleven children, most of whom were born in Coppell.

On August 24, 1896, some nineteen Baptists met to organize the Coppell Baptist Church. Mr. and Mrs. J.B. Harrison, Mr. and Mrs. W.O. Harrison and eleven others who were either Harrisons or future Harrison in-laws became members.

Mr. and Mrs. J. Tyler Harrison moved into what was called "the little house by the bridge" by Coppell old-timers, a house located just across Grapevine Branch from Harrison Hill. Here their three children were born.

Soon after the birth of their third child, Lucille, the family moved to the other side of Coppell, on Cottonwood Branch, where they lived for another year. When Mr. Harrison's father retired in 1902, they moved to Harrison Hill.

Tyler Harrison's business interests were many: a partnership in the Coppell General Store with his father, a private contractor, a cotton and grain dealer, owner of one-half interest in the cotton gin and owner of the lumberyard.

Tyler Harrison bought a plot just east of Coppell, next to the W.O. Harrison home, and erected a seven-room home with a screened back gallery and a large front gallery supported by three Ionic columns. When they moved in, he had a new fainting couch delivered for Mrs. Harrison. It looked so much like a casket that she cried when they brought it into the house. Five months later, on May 3, 1907, Harrison died of Bright's disease at the age of thirty. Three years later, on November 20, 1910, Maud Harrison married Thomas E. Standifer, her late husband's best friend, in Coppell. They had one daughter, Tom Evelyn.

Duncan Harrison was a son of Tyler and Maud Harrison. His boyhood was spent in Coppell, where he completed his formal schooling. He had a

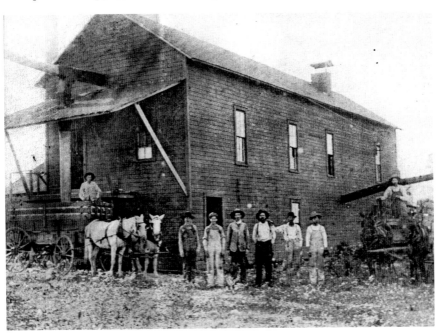

Coppell had two cotton gins, a drugstore, a general store and a number of other businesses in the late 1800s.

first double cousin named Harrison Duncan, and it was their great delight to confuse the teacher in school when the teacher asked either of them a question, wrote Clifton Harrison. Duncan Harrison spent his business life in agriculture and contract work, and he owned the local ice business for many years. He worked for the government during World War II, after which he and E.C. Gentry of Coppell were in the mercantile business. In 1947, they sold this business, and the Harrisons moved to Dallas and worked in warehousing until his retirement.

Clifton Duncan Harrison was born in Coppell on August 21, 1919, in what was called "the little house under the tree." His brother Tyler was born approximately two years later on October 13, 1921, in the same house just east of the main part of town. The house has long since been torn down, said Clifton Harrison, but the old oak tree remained most of his life.

Both sons received their formal education in grade schools in Kopperl, Coppell, Grapevine and some other small schools in Texas. In 1933, they moved back to Coppell to the old Bennett house. From there, they rode what he called the biggest school bus in Texas over the longest bus route in Texas and, along with about thirty to thirty-five others in their age bracket, learned to know and appreciate Uncle Jake Gravley, the bus driver. The route was from Coppell to Northwest Highway to Letot to Farmers Branch and then to Carrollton, he said.

Lorene Pirkle's grandfather Thomas Jefferson Harrison was born on June 4, 1856, in Anderson, South Carolina. He came to Texas in 1870 at the age of fourteen. While riding his horse to the evening services at Grapevine Church, he was converted, she said. He joined the church at Grapevine and later moved his membership to Cottonwood Church, on the western edge of Dallas County. In 1896, he and family members were charter members of the Coppell Baptist Church, along with his brothers and their families.

On November 22, 1877, he was married to Elizabeth M. Sanders, whose family had come to Texas from Tennessee and settled on the Grapevine prairie near the site of Cottonwood Baptist Church on W. Bethel Road. The family name is spelled both with and without the letter *u*, Pirkle said. "Grandma spelled her name Sanders, but some cousins spelled their name Saunders."

The T.J. Harrison home was located in Coppell on West Bethel Road at the corner of Esters Road, today Freeport Road, where Minyard Grocery later built a large warehouse and corporate office, recorded Pirkle. Harrison owned several acres on each side of Esters Road and south to the railroad tracks. There were at least two rent houses on this property, said Pirkle, and

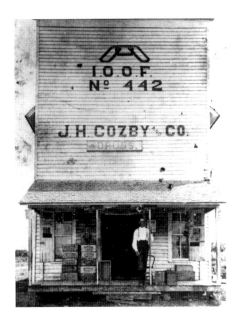

The J.H. Cozby and Co. drugstore was a typical early building with a tall frame façade.

he owned a store building in the business part of town.

"The store burned when I was a child while it was leased as a grocery store. One of the rent houses was torn down, and an Assembly of God church was built on the site," she recalled. "During his lifetime, Grandpa was in the mercantile business with his brothers, J.B.L. and W.O. Later, he was in business with a son-in-law, J.L. Ratliff, and later was perhaps in business alone. His failing eyesight and the fact that he could not turn a needy family down for credit may have led to the end of life in the business world," she wrote. "He also farmed some and raised cows, chickens and hogs. Hog killing time was always a fun time at Grandpa's house. They also had a large orchard and a garden, as most everyone did."

Seven girls and one boy were born to Pirkle's grandparents: Ida, Nora, Ell, Bessie, Cora, Lena, Pearl (her mother) and Nellie. Ida married Elzworth Parr and lived in Coppell all her life. Their home was the future old Coppell Library on South Coppell Road. "Aunt Ida and Uncle Elzie did not have any children of their own, but they 'adopted' all their many nieces and nephews and were dearly loved by all of them. I spent many happy times in their home," said Pirkle.

Nora married John Lafayette "Fate" Ratliff, who became a Baptist preacher. Aunt Nora and Uncle Fate were the parents of six boys and one girl: Tom, Vernon, Carroll, Glen, Grace, Jack and Charles, all of them born in the metroplex area. Uncle Fate was pastor in Coppell from April 1913 to December 1915.

Ell Harrison, the only son of T.J. Harrison, married Ettie Lee Pipes and lived most of his married life in Fort Worth. Bessie married Claude Lee Plumlee, and they lived in Coppell all their lives. They were parents of three girls and two boys: Cleo, Clayta, C.L., Weldon and Willie B. Clayta and Weldon were the only grandchildren of T.J. Harrison, who lived in Coppell.

Cora married Andrew Newton Corbin, and their home was on a farm between Grapevine and Coppell. The homesite is now inside the boundaries of Dallas/Fort Worth International Airport. Cora and Newt were the parents of two boys, Newton and George, but Aunt Cora did not live to raise her two sons, said Pirkle. She died of cancer when Newton was almost eight years old and George only three.

"Pearl, my mother, married Ernest C. Gentry, and their home was in Coppell. I am the oldest child of Pearl and Ernest and have a brother, Ernest E. of Frisco, and two sisters, Charlotte Dearing of Grapevine and Nell Harn of Carrollton," said Pirkle, who married C.F. "Bill" Pirkle and had a son and daughter.

Nellie married Leander B. Whiteside and lived between Grapevine and Coppell on a farm that is now part of airport land. They were the parents of three boys and one girl.

The Moores Gave Moore Road Its Name

In 1876, Charles Moore came from Alabama to Gibbs. He rented a piece of farm land located "on the prairie" and started to work, wrote the late Theresa Eby. He had to haul his water supply from Grapevine Springs, which was not far away. Moore met and married Cora McDonald. After his marriage, Moore purchased 480 acres of wooded bottomland from the Warner, Perry and Griencer families, located west of the Carrollton Dam on the East Fork of the Trinity. For some of the land, he paid only fifty cents an acre.

In 1889, a son, Thomas Bernard, was born. He began school at Bethel School, a one-room log cabin. Miss Anna Moore was the teacher. Several years later, his father bought a 145-acre farm on the prairie where North Lake now sits. Tom transferred to the school at Gibbs because his family believed it offered better opportunities for learning, Eby wrote. As Tom walked to school in Gibbs each day, the only house he passed on his way was the home of Mr. and Mrs. J.B. Harrison and family, along what is today Southwestern Boulevard, an occurrence that would later become significant for him.

After graduating from the eighth grade, Tom continued going to school for two additional years. He sat in the back of the one-room school and received tutoring from the teacher, Ples Corbin, as time permitted. Dr. Jess

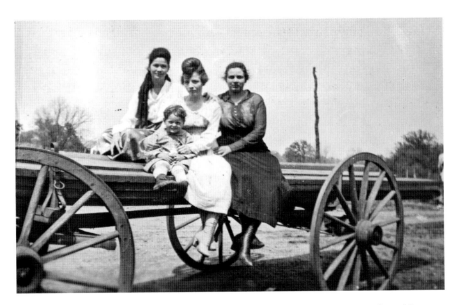

Transportation and trade were accomplished by horse-drawn conveyances such as this lumber wagon.

Bennett built a small frame building about 1905 and opened a drugstore. Tom helped drive the horse for Dr. Bennett when he made house calls.

In 1906, Tom Moore enrolled in the Dallas Business University located in Oak Cliff. After several months of schooling, he began a bookkeeping job with the P&O Implement House, a wholesale distributor for farm supplies. The money panic in 1907 changed Tom's life, said Eby. One morning he went to the bank to make a deposit and cash a payroll check, and the bank president told him there was no money to cash checks. P&O had to close for business, Tom lost his job and he only received twenty of the eighty dollars in his savings account.

He returned to Coppell to his father's farm, and together they went into the hay-baling business. But Tom still preferred the business world to farming, so in 1909 he bought the lumberyard in Coppell. In 1911, he sold the lumberyard and went to work for Eagle Ford Cement Company. In 1912, he began work for Ford Motor Company. On August 30, 1914, Tom Moore and Nannie Mae Shaw were married. Nannie Mae was a nurse in Dr. Leake's Hospital, located on the corner of Pearl and Canton Streets in Dallas. The couple bought a home on Bennett near Ross Avenue, and their first child, Thomas Bernard Moore Jr., was born there. Tom Moore became service manager in the Ford plant in Mesquite, Texas, where the family lived for ten years. During that time, their daughter, Martha Jo (Cozby), was born.

In 1928, Tom returned to Coppell with his family to manage his father's farm. After five years on the prairie, he wanted more land and rented the Whittiken place—the farm and house that he passed each day on the way to school, where the J.B. Harrisons lived. The Moores lived there ten years and during this time were active in the Methodist church, the school and the community. Interested in politics, they helped with national and county elections as worker and judge.

In 1942, the family moved back to Dallas, where they lived for five years before returning to Coppell for retirement. Their last venture was a grocery store in downtown Coppell, not far from where they had built their new home. Thomas Bernard Moore died at the age of eighty-four.

KIRKLAND REMEMBERED NO ELECTRICITY, OUTHOUSES AND SMOKING GRAPEVINE

Early days in Coppell can be reflected in the eyes of someone who was there, and at eighty-eight in early 1990, petite Jewel (known as Jack) Kirkland remembered the days of kerosene lamps, horse-drawn buggies, outhouses and no radio or television. Kirkland had recently been named the "Longest Living Resident of Coppell" at Coppell's first Founders Day, sponsored by the Rotary Club of Coppell. While she was not the oldest resident, she had lived the longest continually in Coppell, never having moved away.

She was born in the home of her grandparents, the Stringfellows, located on what is now Loch Lane in old downtown Coppell. She lived there until she was two, when her parents, John and Jennie Kirkland, built a new home nearby and moved in 1904 across from the old Methodist church at the northwest corner of West Bethel and South Coppell Roads. The home has since been moved to Coppell's Heritage Park and restored, and it is now called the Kirkland House. The Kirklands were parents of eight children. Jack Kirkland lived in the house for sixty years, never marrying. According to Jack, in 1960, she built a new brick home on South Coppell Road, where she still lived in 1990.

The family was Methodist, and Jack's earliest memories stemmed from experiences at church. Her very first memory was of a small car with a Bible picture on one side and a verse on the other. Her mother would read the verses to her and the other children at church. She vividly recalled the joint

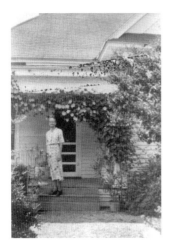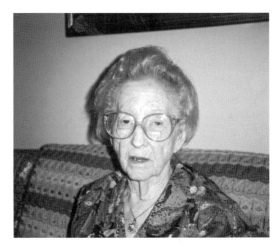

Left: Jennie and John Kirkland built a home in 1904 that today anchors Heritage Park in old downtown and is open for tours.

Right: Jack Kirkland, at ninety, remembered the days of no electricity, no automobiles and outhouses.

services held by the Methodist and Baptist churches at Christmas and her first part in the program.

"I said a little verse," she said, and without missing a beat, she sang, "I'm Momma's little darling, don't you think I'm sweet, with roses on my shoulders and slippers on my feet." Jack Kirkland remembered how excited she was that night and how, because of her small size, she had to be lifted onto a table to be seen by her audience.

She recalled having very tall Christmas trees at the Baptist church, which had a taller ceiling than the Methodist church, but not very bright lights. The trees were set up in churches rather than homes because homes did not have electricity. She remembered getting a doll that Christmas.

One of her saddest recollections was the death of her younger brother, which occurred when he was ten months old and she was four. He died of pneumonia. "That was the first thing that impressed me. I remember more about him than anything. I remember playing with him," she said, as she took out a little black journal to look up the dates.

Jack had three sisters and four brothers; she was a middle child. One of her older sisters, Sallie Brooks, lived with Kirkland in her South Coppell Road home in later years. Brooks, who grew up in Coppell but married and moved away, was one of the area's first schoolteachers, teaching first at Bethel School.

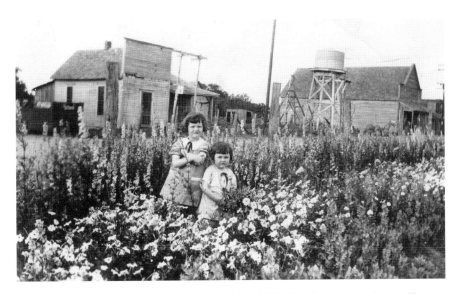

Against a background of the Harwell home and the W.O. Harrison store and post office, the Oscar Cooper children enjoyed a field of flowers.

Her first teacher was Cora Harrison, and she remembered the first day at Coppell's new school. Situated behind and west of what was then the Baptist church on West Bethel Road, the school was close to her home. She moved into the new building, in front of the old school, in the third or fourth grade. "At midmorning, we took our books and walked to the new building," she said.

She vividly remembered the other children bringing their lunch to school. "I was always so envious of that," she said. "I thought it would be so nice to eat at school." Because the family lived so close to the school, she and her brothers and sisters went home for lunch. "A few times, Mama would bring a lunch in a Concord grape basket and that was the most wonderful thing."

She recalled how her sister Sallie went to school the first day but wouldn't go in. "Mama could see her sitting out in front. Mama called her and talked to her; she went back at noon and stayed," said Kirkland.

Jack remembered activities of early Coppell youngsters, such as throwing balls, "ring around-the-rosy" and "jump the rope," as she said it was called then. "We played in our pasture, swung on grapevines, hunted pecans and red haws and caught crawdads. They'd never worry about you. There were a few tramps down by the railroad." She could not remember any killing or crime, but there were fires. "There was no way to put it out," she explained, with no fire equipment or readily available water. Coppell was a farming town, and her father was a farmer. Their farm was situated in the area that

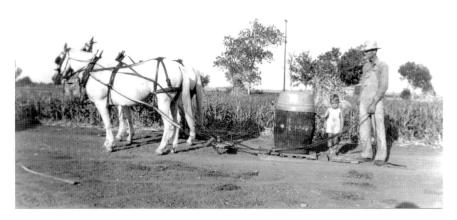

Without electricity and refrigerators, the ice man delivered blocks of ice several days a week.

is Hunterwood Estates today. The family helped work in the fields, hoeing and picking cotton.

"Our Dad didn't expect anything out of us," she laughed.

Another favorite activity during the winter was skating on the creeks of Northlake Woodlands on Saturdays. "We wore the soles out of our shoes. It would burn your soles up," she said, explaining that the kids did not have skates. She recalls "mama half-soleing" the family's shoes. Her mother bought sole leather in squares. "She'd tack it on there," said Kirkland, as she held an imaginary hammer and demonstrated the process.

"We would wade the branches [of the creeks of Northlake Woodlands] and go crawdad fishing," she said. Her brother would trap things "for the fun of it. Mama was a hunter. She went rabbit hunting in the snow the day she saw eighty and got a rabbit."

Kirkland described Coppell as a booming town back then. The big event was going down to the depot to meet the train. The depot was located several blocks south of old downtown, on the northeast side of the railroad track, adjacent to what today is the City Service Center and Life Safety Park. Another community event was watching the local blacksmith "shoe" a horse. "Certain horses were pretty hard to shoe," she said. "We'd say, 'Let's go see 'em shoe ol' so-and-so.'"

The wildest thing kids did back then, she confessed, was, "We smoked grapevine and dipped cinnamon for snuff. It looked like the real thing. That's

the worst thing you could do, was smoke grapevine." She then demonstrated the process as she took a simulated drag. "You would take a knife and cut it and draw pretty hard; if you got hold of a real good one, you could get smoke and puff it out. Our parents cautioned us about burning our tongues."

The family had an outdoor "restroom" (outhouse), as did all Coppell families in the early years. Recalling times during cold weather, Jack said, "You just got used to it."

Her family had a fringe-top surrey. When she was ten years old, she and her sister would take the surrey to Grapevine by themselves. They were not afraid, she said with a shrug, adding, "Nothing happened then, other than a horse running away [with you]. Twenty miles away from home was a long way. When we were going on a long trip, [like] the other side of Fort Worth, we'd put the team [of horses] to it [the buggy]," demonstrating with her hands and torso. Jack recalled going with her family to the Dallas Fair on the train, which she called a big treat.

Her brother had a one-seat buggy "to court in," she recalled with a laugh. "We called it a courtin' buggy, because of the one seat." By the time she was a teenager, old enough to date, her family had a car. For dates, teenagers would go to the "picture show" in Grapevine, Lewisville or Carrollton.

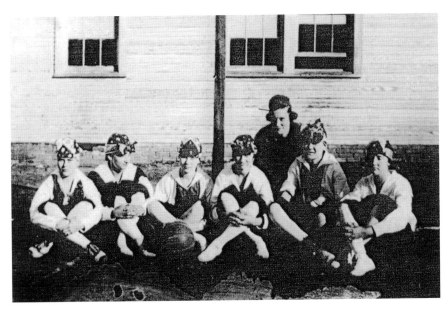

Coppell girls formed sports teams that struggled to learn the game, much less win.

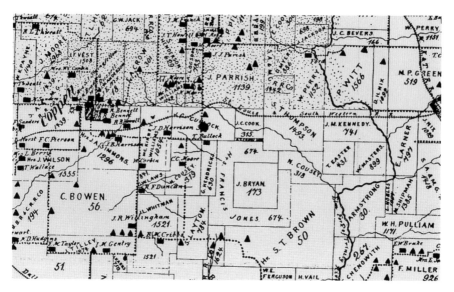

A 1900 street map shows, with magnification, the location of many early Coppell homes.

Everyone went to church services on Sunday evenings. Often, on Sunday afternoons, the youth would meet out at the new Carrollton dam. It was a gathering spot for young people, who would swim, take photos and get cokes from a nearby stand, she said.

The whole community would gather on occasion for picnics and baseball games, with barrels of lemonade to share. Box suppers were held at church and at school, along with joint church revivals.

Jack Kirkland was on the first basketball team at school. "I'd never seen a basketball in my life," she said. The team first played Richardson and got beat 51–1. The next year, the girls were prepared. "They didn't beat us very much!"

Today, the Kirkland House sits one block east in Coppell's Heritage Park and is open for tours, which are based largely on information shared by Jack Kirkland. The four-room frame house was well constructed for its time, according to historic preservationists who helped during reconstruction after the move, with intricate wood cornice and door embellishments and elegant, colorful wallpaper, found to have been from Sears Roebuck. Wallpaper had to be ordered from England to match the elegance of the original wallpaper.

Coppell Girls Had a Feisty Side in the Early 1900s

From all accounts, Coppell girls back in the early 1900s had an independent spirit. They reported such activities as smoking grapevine, climbing windmills, walking on railroad tracks to school, skipping school and regularly taking off in horse and buggy for Grapevine. Three old-timers between the ages of eighty and ninety admitted smoking grapevine, including Eva Belle Parrish, who confessed at ninety-five in front of her preacher.

As feisty today as she probably was back then, Zelma Sanders Plumlee, who turned ninety on December 10, 2005, was honored at a birthday party at the Coppell Senior Center. She shares the birthdate with Lorene Gentry Pirkle, a fact they enjoyed when Zelma's dad, a farmer, moved the family to Coppell when she was around ten. Seeing each other at meetings, they yelled out, "Hello, twin!" Zelma and Lorene were related by marriage. Zelma married Weldon Plumlee, grandson of Thomas Jefferson Harrison and son of Claude Plumlee.

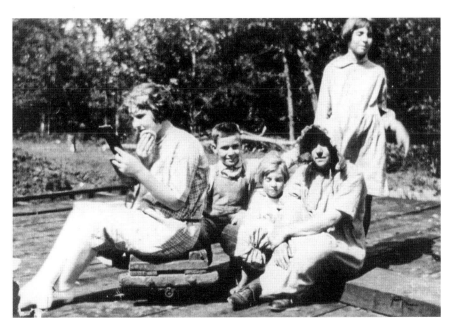

Coppell youth, who enjoyed a lot of freedom, hung out on old Denton Creek bridge.

Zelma Plumlee attended school in the two-story frame schoolhouse in old downtown, beginning in the fifth grade. In the seventh grade, she remembered "playing hooky [with some other girls] to go to Dallas in Sam Long's Model T Ford" when she was supposed to be taking a test to be promoted. When asked what happened, she said, "I went through the seventh grade twice."

Her family worked the Lesley farm, situated along Interstate 635 and South Belt Line. She recalled picking cotton until her back hurt and missing three to four weeks of school each year because of working in the fields. The family first lived near Esters Road on the west side, and she walked to school, explaining that she "walked the railroad [tracks]. I could walk the rail because I didn't want to get [my] shoes scuffed by walking on the ground," she said. She, too, smoked grapevine, saying, "The first time, it made me sick. I had to go to bed."

From the time she was twelve, she made her own clothes. "I sewed for people—fifty cents to make a dress, no patterns. I made Martha Jo Cozby's clothes, [and] my dress for the high school choir."

The Trinity River was "our swimming pool, where I was baptized," said Plumlee. Later, people went to the Lancaster farm in far northwest Coppell [Wagon Wheel area], where a real swimming pool served this purpose, she said.

Youth were allowed to roam and ride freely, without fear of crime.

Zelma married Weldon at eighteen, and they lived for a time in the section house of the old railroad depot complex on Southwestern Boulevard east of South Coppell Road. According to Plumlee, the railroad declined because the cotton gins had closed down.

At ninety, Zelma still cooked, and on a recent occasion she had cooked lunch for eighteen family members. She recalled every dish, saying, "I went to the grocery Monday and bought the

groceries—two pounds of ground meat for meatloaf, chicken and dumplings, black-eyed peas, macaroni and cheese, salad, potatoes and cantaloupe."

Mildred McCord Cherry, at ninety, another livewire who lived in Dallas, drove herself from Dallas to Coppell to share her early memories. She attended the old two-story school, and in the second grade she entered the Dallas County Spelling Bee. She ended up in a tie with a fellow Coppell student, Anna Sanders. The girls received "$2.50 apiece and gold rings." Mildred said her grandmother had an old blueback speller, and "that's how I learned to spell."

Mildred moved from Coppell in the fourth grade. Her grandfather McCord rented farmland from the Thweatt family. She remembers cotton growing so high that you could walk in it and not be seen. According to Mildred, some of the Thweatts "speculated in oil and became quite wealthy." Down at the depot, people gathered in the evening for entertainment. "We used to vie with each other who could spit the farthest," said Mildred Cherry.

A tomboy, Mildred said she loved to climb but was "afraid to come down. I have an avid curiosity. We traveled all over town in those years, often barefooted." She remembers swinging on grapevines, and once she climbed up an old windmill with her grandmother's silk umbrella, thinking she could fly or sail down. But she wouldn't climb down at her grandmother's request, adding with a grin, "She had to climb up and get me."

Even older than Zelma and Mildred, Ruby Hood McDowell, who passed away at ninety-seven in 2001, was still planting and tending her traditional garden in her yard at her home on Bethel School Road, a section of a street that was later closed to through traffic. She contended that work kept her alive. She still crocheted, cooked and cared for herself. Typical of the independent style, she wanted to stay in her home, refusing offers from family members for other living quarters.

Ruby McDowell was born in 1904 in Coppell to Robert T. and Lou Alma Orum Hood. Ruby's father also farmed Thweatt land in the vicinity of Town Center, and the family lived in a small frame house just east of North Denton Tap Road at Parkway Boulevard today. Ruby provided old photographs to show the one-hundred-year flood, when the Town Center area flooded and family members were up to their ankles in water.

Young Ruby helped out with farm chores, climbed the old windmill nearby and hung out along the old Denton Creek Bridge with her friends, posing for many photographs. Along the way, she became buddies with another old-timer, J.C. Thweatt, and he called her one of his best friends when both were in their nineties. Neither of them minced words. Living

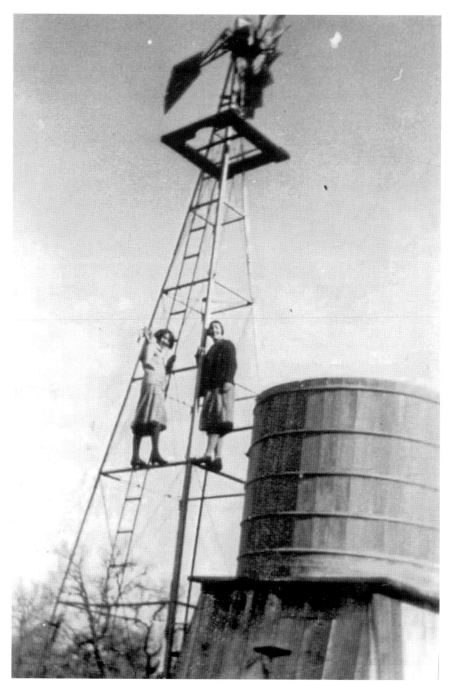

Climbing a windmill was another typical youth pastime.

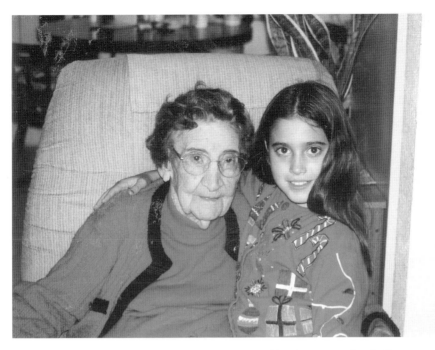

Ruby McDowell, pictured here at ninety with her granddaughter, was a daredevil teenager in the early 1900s.

only a block from each other in their later years, they spent many hours visiting, and she would cook chitlins and cornbread for him.

In 1999, Ruby McDowell, at ninety-five, rode in the Coppell Christmas Parade and was honored as the oldest living resident born and raised in Coppell. She called it the "most fun day of my life" and didn't want the parade to end. Up until the end of her life, she was still crocheting quilts for her many family members, which included twelve grandchildren, seventeen great-grandchildren and one great-great grandchild.

Jack Kirkland, Zelma Plumlee and Eva Belle Parrish, each of whom also smoked grapevine, lived into their nineties.

Perhaps old-time males didn't live long enough to tell similar tales; although, these same girls were quick to report on the men gambling, playing dominoes, chewing and spitting. Spitting seemed to have been a premier entertainment activity back then, even among females.

Harwells Reflected Turn-of-the-Century Life

Local historian and longtime Coppell teacher Wheelice "Pete" Wilson Jr. wrote a story about a typical day in early Coppell, based on a day in the life of resident Clayta Harwell. The story, based on actual events, reflected the busy life of a typical Coppell family. Floyd was the local barber, and Clayta worked at the railroad depot, delivering mail to the local post office. Years later, she began to cook for Coppell schools.

By seven, Floyd had finished his eggs. He bundled up and went outside to open the shop and to get out of Clayta and Billy's way while they completed their preparations for leaving the house. The barber shop was attached to the house, but, by state law, it could not have an adjoining door. Floyd started the kerosene fire in the shop and started heating some water. Shaving was the first chore after breakfast. He was his own first customer of the day.

He might be his only customer today, thought Floyd. It was Monday and quite cold. But that would be alright with Floyd. He would have time to sit in the big barber chair and read the paper. By late afternoon, he would write a few sentences in his spiral-bound diary. It was 1942, and the haircutting business in Coppell was pretty good.

Before he and Clayta moved to this corner, he had leased a shop about a hundred yards east, next to the general store, where he offered haircuts for thirty-five cents and baths for twenty-five. He still remembered the night that several of the buildings along Bethel Road, including his shop, caught fire and were destroyed. Neighbors were barely able to drag out one of Floyd's two heavy barber chairs. The only valuable property he lost in the fire, besides one chair, was his set of double mirrors. He and his twin brother Lloyd, practicing barbering together, had reluctantly gone into debt to purchase the mirrors. Floyd would finish paying for them after he had set up shop temporarily in Emmet Gentry's garage. The move to his present shop, a converted room in his new house, was a happy one. Floyd would make only one more change in his business location before the end of his career, moving in a small building from Farmersville to be his shop. The building is still a barber shop on the corner of W. Bethel and S. Coppell Road, and the house today is occupied by Coppell Home Décor and Old Town Mercantile.

The farmer's life was nothing new to Clayta. She had grown up on a farm only a mile away. Throughout the years of her childhood, she had come to town down the same road she was now driving, except that her

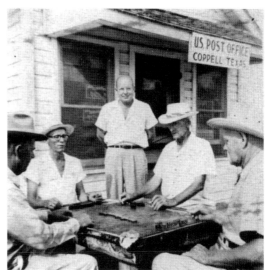

Right: Domino games were frequent in old town, often in front of the old post office building.

Below: Floyd Harwell, the local barber, right, in front of his shop in old downtown.

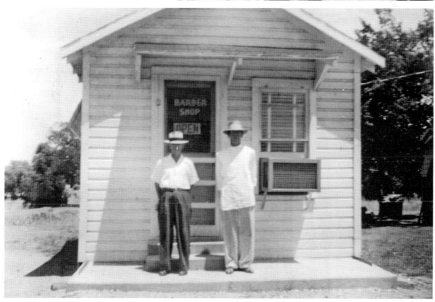

father used a horse-drawn buggy. Clayta remembered that in those day, her father's buggy would often pass Dr. Jess Bennett, driving his own buggy back into town after spending the night on one of the neighboring farms helping with the arrival of a newborn. Jennie Kirkland would sometimes be in the buggy with Dr. Bennett. She was his aunt, and she owned a large collection of medical books and was a good midwife. Aunt Jennie often helped out in medical emergencies.

Turning south to where the Woodmen of the World lodge hall used to stand, Clayta considered stopping in at her parents' house to see if her mother's health had improved. By June of each year, when summer vacation meant that Clayta did not have to tend to her second job at the school, she would sometimes avoid using the Ford and would walk to and from work. Her Aunt Myrtle Hurst, who had been the railroad agent before her, had also walked, usually pulling a little red wagon so that she could bring back the mail that came in on the train.

In those days, the mail had to be delivered to Minnie McGee's drug store; there was no separate post office. The drug store, although it was not the first one in Coppell, was by far the most elaborate retail building in town. On the front were large windows, decorated with stained glass. Steep concrete steps, unique in Coppell, led up to the double front doors. Inside, Minnie stocked every patent medicine imaginable and could fill any prescription that the doctor ordered. The most impressive part of the store, however, was the soda fountain. Minnie's husband Brian had been killed behind that soda fountain when a compressed gas cylinder exploded.

Twice per month, on Saturdays, Clayta had to spend most of the morning at the depot. On those days, Floyd would go to the station ahead of her and fire up the stove so that it would be toasty warm for her to work. In summer months, the tall ceiling and long windows of the building would make her work comfortably cool. Billy would often accompany her and play with his dog Snip.

Clayta had been taught to fill out the railroad reports very carefully. They were sent to the local office in Tyler. When it was report time, she would seal the papers in a large envelope and put them in the mailbox just outside the depot. When the next train saw that the flag on the box was raised, it would stop to collect whatever Clayta had put there. Myrtle's predecessor was Oscar Cooper, who was the last full-time railroad agent in Coppell. The old depot over which he and Myrtle had reigned was a tremendous business establishment, not like the two-room affair that had replaced it only two years ago. In those days, the railroad through Coppell was a dominating influence, with passengers arriving and departing twice daily. They bought tickets to Dallas to shop or to Fort Worth for the livestock show. Incoming shipments weren't just a few boxes, but included many crates, some containing staples to stock the local stores, and even lumber from East Texas to build houses.

Now, in the frosty morning air of an era that depended less on the railroad, Clayta looked over the freight that had arrived on the early train.

Her long day had just begun.

Coppell youth helped with chores.

Corbin Gave Hefty Inheritance as Children Turned Twenty-One

George Corbin, who headed another early Coppell family, must have been a successful farmer, because he gave each of his many children an interesting endowment that would be envied today. Corbin came to Texas in 1863, after the war, and settled in the old Cottonwood community on today's far west side, west of Freeport Parkway and east of Grapevine. The Corbins had twelve children, several of whom died in infancy.

When the children turned twenty-one, Corbin gave each of them a horse, bridle and saddle; a cow and calf; a saw; one thirty-pound featherbed; and $500 toward the purchase of land, which in those days would have been a windfall.

A son, Pleasant "Ples" Corbin, trained and became a teacher in both Bethel and Coppell Schools. After marrying, he settled in a home on South Coppell Road, across from what was later the first library. Ples Corbin was a member of the old Cottonwood Baptist Church and then joined Coppell Baptist Church when Cottonwood dissolved. Ples Corbin died in 1964.

7

Coppell Had Grand Homes

While early Coppell was primarily a farming community, the town had its share of grand old homes. Around 1865, Washington Curtis Bullock built a brick home on his 480-acre tract between Grapevine and Denton Creeks, on the northwest corner of Bethel School Road and South Denton Tap Road. Said to be the first brick home in Dallas County, the two-story home was built from brick handmade at the creek in back of the house. The land was later acquired by Walter Thweatt, son of Joseph, who lived in the home but later tore it down and built a white-frame home. The land is now a subdivision, but the Bullock Cemetery remains on the property.

One of the most elaborate homes was the Sanders home on a hill on the far west side of Coppell, on the north side of W. Bethel Road where CiCi's corporate office sits today. The two-story white-frame house, covered with gingerbread trim, later belonged to descendants, the Plumlee family. But history was lost when the home burned as it was being moved into old downtown.

Also on the far west side, on Esters (now Freeport) Road where the Minyard corporate office would later be located, was the Thomas Harrison home. The home was a white, one-story frame with a large porch that extended around the side. The family later added fancy gingerbread trim.

The Kirkland home, built by Jennie and John Kirkland in 1904 and probably the oldest remaining house, had elegant wallpaper from Sears Roebuck that had to be reproduced in England during restoration. The home now anchors Heritage Park in old downtown.

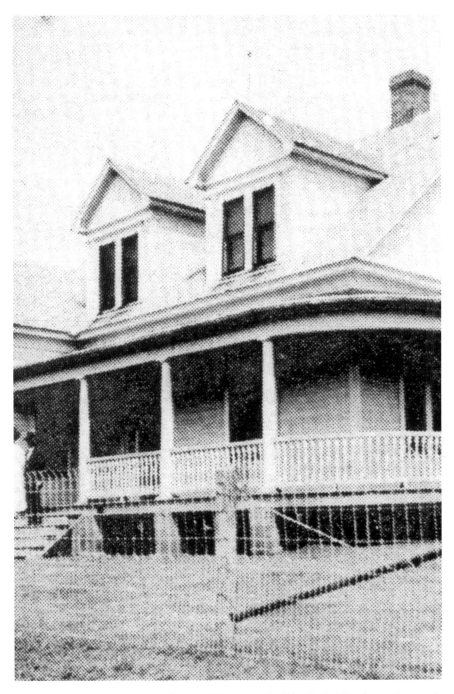

One of Coppell's finest two-story homes, which sat on far West Bethel Road, was destroyed by electrical fire as it was being moved to old downtown.

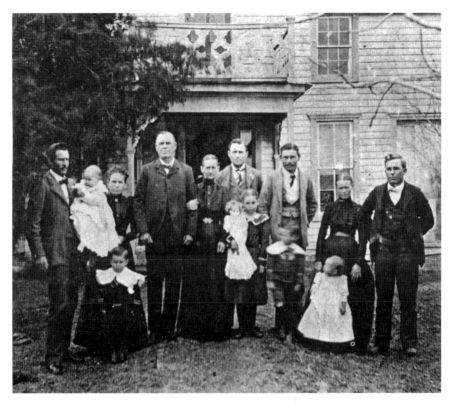

Burrell Howell and family built a two-story frame home in Coppell just north of today's Pinkerton Elementary School.

Banker Nicks also had a large, fancy home in old downtown on South Coppell Road, according to old-timer Zelma Plumlee.

East of old downtown and just north of the railroad track, adjacent to Grapevine Springs Park, was the Burrell Howell home, a large two-story white frame home.

Other early homes in old downtown along West Bethel Road belonged to W.O. Harrison, J. Tyler Harrison, Dr. Jess Bennett and Oscar Cooper.

Youngsters Were Served
by Three Area Schools

Gibbs and Coppell School
Provided Education in Old Downtown

Old-timers recalled that in early days, the Coppell area had three schools that served different sections of the community. Bethel School served the Bethel community on the east side of town, Gentry School was formed for children to the south and Gibbs (later Coppell) School met in the Methodist church in old downtown Gibbs before a building was constructed.

Later, the first small frame structure that housed the school was located southwest of the old Baptist church, behind the future John Arnett family home, on land donated by Henry Bennett, according to research by the late Theresa Eby. The site is today the location of the Bennett Ratliff office complex in old downtown.

Then in 1911, a two-story frame school was built in front of (north of) the small school, according to numerous old-timers who attended both schools. The concrete slabs, poured in the foundation rim, were uncovered by the Coppell Historical Society during archaeological exploration in early 2012. Concrete blocks from the foundation were used in 2015 to build a border around a community garden beside the Farmers Market pavilion in old downtown, identified with a historical plaque.

Both downtown school buildings were south and slightly west of the intersection of West Bethel and South Coppell Roads. Once the new two-story school was completed, student Jack Kirkland recalled the move. "At

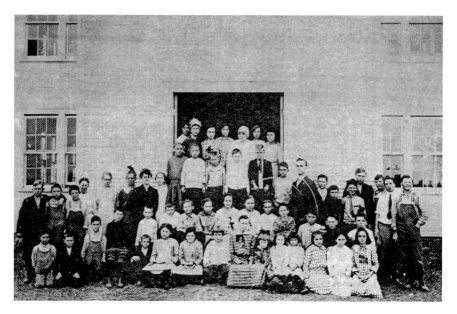

Coppell School, a two-story frame building, was constructed in old downtown in 1911.

midmorning, we took our books and walked to the new building," she said. The new school opened when she was in the third or fourth grade.

Zelma Plumlee, Eva Belle Parrish and Mildred McCord also described attending the new school. First, second and third grades met in one downstairs room, fourth and fifth in the other, with a hallway in the middle. Sixth and seventh grades met upstairs. Eight acres of meadow were in back. Plumlee recalled that there were no restroom facilities, and students used Sears Roebuck catalogues for toilet paper.

An unidentified Coppell old-timer also wrote about the two-story school, describing desks in rows and several grades in each room. The first principal the writer remembered was "mean and run off," followed by Mr. Flagg, a nineteen-year-old army man sent by the government, who wore a World War I uniform. "He was adored by the girls and challenged by the boys," said the writer, adding that the two-story school was later bought by Red and Pearl Stringfellow, and two houses were built out of the lumber from the school. The Stringfellows rented one of the houses, lived in the other and ran the local phone office in the front room.

According to Clifton Harrison, former Coppell resident, Ples Corbin had trained and become a teacher in both Bethel and Coppell Schools. After marrying, Corbin settled in a home on South Coppell Road, across from

what was later the first library. Said Harrison, "It was he who introduced my brother and me to the reading of good books, many of which were from his own personal library. He instilled in us high ideals and principles for living that have been an integral part of our lives and the lives of many young people in the Coppell area."

Another well-liked teacher, according to Harrison, was Sallie Kirkland Brooks, born in 1899 in Coppell, the daughter of Jennie and John Kirkland and sister to Jack Kirkland. She taught in Bethel, Hackberry and Coppell schools. "Miss Sallie, as we always called her, got me to reading the World Book in my extra time, and that became my reference," said Harrison.

Recalling the two-story school, Eva Belle Parrish, at ninety-five, said, "I walked to school on a plain old dirt road, a lane. If it rained, you couldn't go to school or you would bog. There were not too many roads then, mostly gravel. Grampa used to have us sit in the buggy. I had to sit in the backseat. The boys wanted to ride the new school bus. We played old-timey games, round the rosies. I didn't like any games we played if it was a lot of running."

Gentry School Served South Coppell Area

In the 1890s, the settlement of Coppell drew residents from a large area, including land to the south in today's Irving. Coppell Road (now South Belt Line) extended south into Dallas, according to a map from the late 1800s. Gentry School was started to serve Coppell students, and a number of Gentry descendants still live in Coppell.

In 1878, two brothers, Alexander and Milford Gentry, at ages twenty and twenty-two, trekked from Bibb County, Alabama, to North Texas, arriving with little money but a love of the land and farming. Milford began to acquire farm animals and equipment, then acreage. The brothers eventually owned vast acreage in what is now the Valley Ranch–Irving area, including land on which D/FW Airport now lies. Milford gave the right-of-way for construction of Northwest Highway, now State Highway 114. Alexander and his wife raised eight children.

Before 1898, children living in the Valley Ranch–Irving area traveled over hill and valley, often by foot, to attend Bethel School in Coppell, on the far east side, recorded Pirkle. But in 1898, largely because of Alexander's eight children, the brothers decided to bring education closer to home, creating the first school in the area. A small, one-room frame school was

constructed on Milford Gentry's land on Gentry Road, south of Interstate 635 at current South Belt Line Road. Gentry School educated hundreds of local children for twenty-eight years. Students attended Gentry School for seven months of the year, October through April, for seven years before going to high school for four years. In 1926, Gentry School was consolidated with the Coppell School.

In 1882, Alexander and Milford Gentry listed among their property for tax purposes the following: "two horses/mules—$80, tax—$2.47; land, 65 acres—$520; one wagon—$25; tools, etc.—$25." Milford Gentry's land holdings increased from 65 acres in 1882 to more than 1,200 acres in 1900, with a taxable value of $11,460.00, resulting in total tax for the year of $93.62.

Alexander Washington Gentry married Amelia Burden in 1887 in Tarrant County, Texas, and they had eight children, all born in Dallas County: Luther Cain Gentry, John Emmett Gentry, Hattie Beatrice Gentry, Ernest Clair Gentry, Jesse James Gentry, Thomas Clifford Gentry, Floyd Alex Gentry and Bennett Gentry, the youngest, who died in 1993. Alexander Gentry died on February 27, 1928, at the age of seventy.

Isaac Milford Gentry was born on April 14, 1856. He married Louise Battig in 1892; they had no children. When he died on June 29, 1903, at the age of forty-seven, he was honored with a resolution by the Coppell

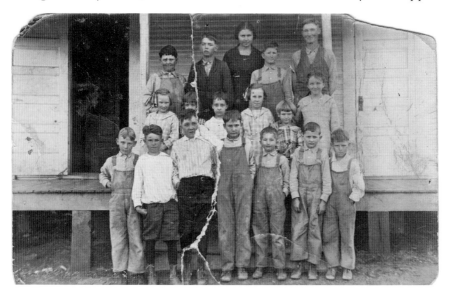

Gentry School served Coppell students in the south part of town, today's Irving.

Lodge No. 442 IOOF as "a friend to the widow and orphan, and an honor to the community in which he lived." He owned more than 1,200 acres of land in what is now the Irving area. Members of the Gentry family compiled and published a family journal titled *Isaac Gentry and Descendants*, chronicling the history of the family.

Bethel School's Hilarious Times Described by Ledbetters

"We were all 'have nots' but we weren't aware of it," said Bernice Ledbetter Graham, a student at Bethel School who in later years wrote one of the most descriptive and detailed accounts of Bethel School and Bethel community, best told in her own words:

> *Back in 1916 and prior, Bethel Community School, District No. 97, was located in the northwest part of Dallas County, about two miles due east of Coppell and one-quarter mile north of the Cotton Belt Railroad and Grapevine Creek. Presently the site is at the intersection of Bethel School and Moore Roads, on the southwest corner. Located at the same site of this once proud one-room learning institution was the community Baptist church. The school and church grounds were surrounded on all sides except the north by beautiful trees and pasture land.*
>
> *In that cold and snowy January, my twin brother Buren and I started to Bethel in the first grade. I remember the snow and cold because it was on such a night, January 12, that the second set of twins, Marjorie and Morris Lee, arrived, making six Ledbetter children and the oldest, also twins, just seven.*
>
> *The farm was surrounded on the north and west by the Caddo mounds that circled southeast about a mile from our place. The farm sloped east toward the Elm Fork of the Trinity River. In the winter, how the wind whistled on top of and around those hills! After carefully and tightly overlapping our union suits at the ankles, pulling on heavy, ribbed stockings, high lace or button shoes, a stocky cap, and all the warm outer garments we could find, we would start walking to school. Some mornings a last-minute repair to shoes had to be done, as wet feet all day was an almost sure way to get pneumonia. Daddy would get out a large sheet of leather, the shoe stand and proper sized last, his sharp knife,*

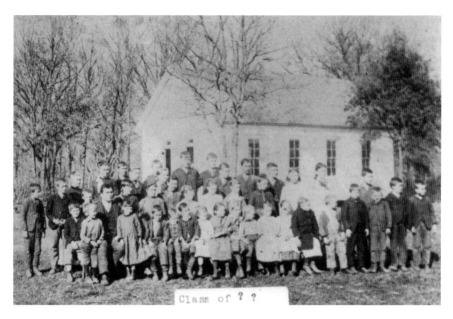

Children walked from all over the east side of Coppell to Bethel School, on today's East Bethel School Road.

hammer and tacks. Soon a nice new sole was on the shoe. Any repair to the upper part of the shoe was sewed with an awl.

During the period of a few years, several families lived on the adjoining farm south of us: the Evanses, Weldons, Allens, and Nobles. In 1918, the Bond family lived on our place and went to Bethel. In 1916, they had come through the country in a covered wagon and picked cotton at our farm. In 1917 Henry and Floyd, Mellie and Hattie Smith lived on the farm and went to Bethel. Later the Polks lived in the same house.

From our house to the gravel road that led north to school was a distance of about one and one-half miles, where there was no road, only cow trails. Our friends to the immediate south and east would either come by the house or join us at the foot of the hill, and we would go over to one of the Caddo Mounds to the big two-story house of Mr. Tom Bullock. His daughter, Minnie McGee, died in January, 1974. In bad weather she was often at her father's big home and in cold weather would ask us in to warm by the large fireplace. Later, Edna McAnally lived in the big house.

At the gravel road, we merged with children from the southwest and west—the Hodges, Ottingers, and Wrights. As we walked north, the Thompsons, Crows, and Yorks approached from the east and the crowd was

complete when Althea Cribbs joined in. She lived just south of the Cotton Belt Railroad track. At the same time, outer families were approaching from other directions—over a period of several years we remember children from the following families: Long, Prater, McDonald, Houston, Stout, Waters, Bob Moore, and Walter Moore's foster girl, Mary Pugh, George, Gordon, Essie Silk, Aught, Tato Asch, Whatley, Keener, Parrish, Duwe, Sasse, Wheeler, and Hurst.

 In 1916, there was only one room, and all grades were taught there. The teacher taught according to the need of each student; as a student was promoted, the teacher taught him or her in the next grade as long as he or she chose to attend school or could afford to buy books and school supplies. I do not recall that we were ever without proper books. An old card in my possession reads, "State of Texas Free Text Book Card," dated 1919–1920; so apparently the free text book system was in effect by 1919. Without return of all books, the pupil would not be granted free texts for the next term. The entire list of "Texas Free Text Book Card" for elementary grades (elementary then included the 7th grade) contained only 25 books. Among the list were such books as Mental Arithmetic, Child's World Reader Book 1, 2, 3, 4, and 5, the Story of Cotton, and Human Body and Its Enemies. The length of the school year varied from one year to the next. In the years 1916–18, with W.L. Gregory as teacher, school started October 15 and was out May 17—seven months. During 1918–19 with Mrs. J. Clyde Drury as teacher, school began October 7 and ended May 2—seven months. During the year 1920–21 with Mrs. Sallie Brooks as principal, school began September 20 and ended April 1, 1921, six months plus.

 How delightful the walk to (Bethel) school was in the spring. We chose many paths, often following along where there was an abundance of wild flowers. The big patches of bluebonnets were beautiful and still dot the hillsides like blue blankets in early spring; buttercups and dandelions were plentiful. We would walk at the foot of the hill or over the top (North Lake area today), often changing our course from one hill to another. There was one hill which was especially steep and we often chose it when walking from school; we liked to see who could get to the top first. At the foot of this particular hill was an old abandoned house, and walking through it was an adventure. We might follow the winding course of the branch, watching a golden, shiny, multicolored perch swimming in the shallow water. Taking off shoes and wading was a temptation we couldn't resist, although we had been told not to do so. Buren and A.D. might make a slight detour to see if

they had caught any animals in their traps. The furs were eventually sold in Dallas. Sometimes we walked east on Cotton Belt tracks and then across the hill home. Our parents cautioned us about approaching trains, and always before going over a trestle we would put our ear to the iron rail as vibrations could be heard from an approaching train that was miles away. It was a thrill to see the hand cars the repairman rode on.

Then there was the dipping vat east of the gravel road, and it was interesting to see the cows go down the concrete ramp and disappear completely into the medicated vat. Farmers were attempting to eradicate ticks. Trudging along the road, laughing and talking—the boys sometimes going into the dry Grapevine Creek bed—listening to the birds and watching the cattle graze, telling "secrets"—how much fun it was! This walking and talking together was a true course in social studies, but no one realized it at the time. Lifelong friends were made in this manner.

Country children really didn't need any additional exercise, but we had a basketball court, volleyball court, and baseball field. The really fun games for girls were Hopscotch, London Bridge, Mulberry Bush, Drop the Handkerchief, Farmer in the Dell, Crack the Whip, jumping rope, and ball and jacks. The boys played marbles, tops, Leap Frog, baseball, and the forbidden Mumblety-peg with a real knife. Then there were sling shots and the ever exciting game of a good fist fight.

Buren remembers the bigger boys who were probably 13 or 14 playing dice behind a pecan grove on the grounds. The teacher became suspicious when a lookout boy kept peeking around a tree. A younger boy told the teacher they were playing with dice, but she could never find anyone with dice. Finally the younger student led the teacher to the west side of the school and uncovered the buried dice.

We started each school morning with a sing-song. During 1917, the year USA landed troops in France, we sang a lot of patriotic songs, and I recall feeling that I would surely burst with patriotism. We marched up and down the aisles and around the walls singing Battle Hymn of the Republic. Buren recalls that if a student were caught not singing, he was brought to the front of the room. Another punishment was to stand in the corner with a dunce cap on.

There was no class distinction in our school—we were all "have nots," but we were not aware of it. We did not realize how overcrowded we were (our homes were overcrowded, too) or how overworked the teacher was. The sticky black mud we walked through to school would make national "disgrace" headlines today.

A typical large Coppell family.

Sallie Brooks was a beautiful young teacher, and 1920 was her second year to teach. Her first teaching experience was at Round Grove near Lewisville, where she made $65.00 a month. During the summer of 1920, she had married Harvey Brooks. In the 1920–21 term at Bethel School, she drove a buggy from Coppell. Before leaving for work each day, Harvey put kindling in the buggy to enable her to start the coal burning in the big school stove. When school ended, Leroy Crow went to the back of the church to harness the buggy for her ride home. Brooks said she devoted her nights to grading papers and planning lessons. Another duty was to take the school census and estimate the books needed for the coming fall. She personally went to the county superintendent's office to pick up the books.

Once, she discovered an "odor" problem in the school room. It was winter and two young trappers, Buren Ledbetter and Alvin Hodges, had a trapping mishap coming to school, and as the room warmed up, Brooks finally had to ask them to go home and change clothes. After a while they returned, and the odor, though lessened, still persisted. The boys blamed the odor on their shoes, explaining they were wearing their only pair. In later years, Alvin confessed that they went to Grapevine Creek where they broke the ice and washed as best they could since they were afraid to go home.

The furniture at Bethel School was simple, consisting of double and, in some instances, single desks with a shelf underneath for storing books not in immediate use. There was an ink well on each desk and indentation for

pencil. For recitations we were called to the front of the room and sat on a long bench. At the same time, others were preparing lessons. For working math or algebra problems, we had ample blackboards. There was a large cloak room (no lockers) and a big stove. The bigger boys brought in the wood or coal and assisted in keeping the fire burning.

Our old school facility consisted of an old iron, hand-operated water pump and two outhouses, one for girls and one for boys. There was no lunchroom, and students ate frequently on the southeast porch. Buren, my brother, and I carried our lunch in a single gallon syrup bucket with the lid perforated to prevent sweating of food. Inside were such delicacies as homemade biscuits, sausage, ham, hard-boiled eggs, sweet potatoes, biscuits with butter and jam, and tea cakes. At times during World War I, only cornbread was available. We also carried vegetables from the garden, including onions.

I always considered myself lucky if I could swap food with some of the German-descent children. They always brought such delicious light bread and pastry. One day I had made a swap with Alvina Sasse, and her little brother Willie said something to her in German. Buren asked Alvina what he said, and she said he told her if she didn't quit giving the food away, he wouldn't have anything to eat. Alvina told him she had only swapped food. When A.D. Ledbetter, another brother, started to school, I no longer shared my syrup bucket lunch with my brothers. The boys often ate and played ball at the same time.

One time, Brother George Thompson preached the funeral of a lady in the neighborhood, and school turned out to attend the grave services in the cemetery across the road from the schoolhouse. She probably died with the flu, so fatal following World War I in 1918–1919. One day we heard a terrible noise in the sky, and all ran outside the school building to see an airplane just above tree level that was having engine trouble. This was the first airplane I had ever seen. Buren recalls that a mechanic from Dallas was called, and eventually a big crowd of neighbors gathered. When the airplane was repaired, it made several upward spiraling movements to gain altitude, and then suddenly swooped downward, barely missing the crowd.

An all-day church affair at Bethel was a memorable occasion, with dinner on the ground and a program which consisted mostly of memorized Bible verses, taught by Mrs. George Thompson. I recall seeing a small trunk literally packed with food.

The number of children in the families increased—the final number in ours was nine, and in the Hodges, thirteen. The boys and girls in the

Hodges family had interesting names: six boys—Albert, Alvin, Calvin, Melvin, Marvin, Melford; seven girls—Erline, Pauline, Maurine, Ethylene, Charlene, and Geraldine and Claudine, twins.

By necessity, a second room was added where the elementary grades were taught. In 1921–22, Mrs. Brooks taught in the "big room," and Miss Winnie Purnell taught in the "little room."

We had fund-raising box suppers. I thought those boxes decorated in roses made out of colored crepe paper were the prettiest things I had ever seen. The highest bidder on a box had the privilege of eating with the girl or lady who brought it. Each box contained luscious pie or cake.

Valentine Day was a big event, and practically all valentines were homemade. At Christmas time we decorated the schoolroom with chains made out of paper and colored with Crayolas. They were pasted together with flour paste. Some children brought bells. We did not exchange gifts; about all anyone ever got, even at home, was a stocking filled with nuts, candy, apples, and oranges.

There was a branch between our home and the gravel road, which became impassable after only a small rain. Daddy built a footbridge across the creek. At the present time, all that land is submerged in North Lake.

Those cold mornings and those terrible chores before going to school, milking two to three cows; this chore fell to Buren and me as we were the oldest. The cows always gave less on cold mornings, but the calves got fatter. And after school—picking that cotton until around Christmas time, churning for butter that never seemed to rise to the top, those bog gardens we assisted with, the shoveling of fertilizer from the barnyard lot, the water we pumped and carried uphill, the babies in the families who had to be watched. There was no escaping work…

We were a privileged group as we were the last generation to really know how to work and be ambitious—yet able to make out with what we had. By the time we reached young adulthood, the 'New Deal' had begun, and the nation had become progressively socialistic since.

Early Churches Bound the Community

In early writings, old-timers referred to early churches—Bethel Church, a Baptist church in the Bethel community on the east and Cottonwood Baptist Church, on the west side of town. Bethel Church was described by Bernice Ledbetter Graham in her writings about Bethel School. Freewill Baptist Church, organized in 1885, was built near Bethel Cemetery, according to Margaret Ann Thetford, who researched early Dallas County records for a June 29, 1989 *Dallas Morning News* article. The church later became Bethel Church. Little documentation has been found about Cottonwood Baptist, other than many area residents attended it and later formed the Baptist church in old downtown Coppell.

Churches were a source of not only religious life but also social life in early Coppell. Their histories, sometimes humorous, were recorded in church minutes and the memories of early members and pastors.

Methodists Construct Building

The first church in Gibbs (Coppell), Grapevine Methodist Episcopal Church South, was established September 17, 1879, according to records of the late Theresa Eby. One acre of land in old downtown, at the northwest corner of today's South Coppell and West Bethel Roads, was donated by Mr. and Mrs. John M. Stringfellow, whose home was nearby. Trustees of the church were W.E. Thomas, J.B. Bennett and Burrell B. Howell.

The church, which developed from a mission known as Grapevine Springs Mission, was known as Grapevine Springs Chapel, later becoming a Methodist church. The group first organized and met under a brush arbor at Grapevine Springs. Around 1850, people began to band together for religious guidance and out of their "steadfast, self-controlled personalities, the future began to become reality," wrote Eby.

Before the erection of a building, the congregation held services in a little log cabin a mile east of the first site in old downtown, Eby wrote. After the donation of the land, a church was soon built. Before it was completed, the congregation was so eager for a place to worship that it held services in the building before a wooden floor was built. The rough, hand-hewn logs served as benches during that time.

The Baptist congregation met with the Methodists during the early years, and the church was used for ten years on weekdays as a schoolhouse. The original communion table built for the church was still in use many years later, and the original church building served the community for about a decade before a new building was constructed, according to Eby.

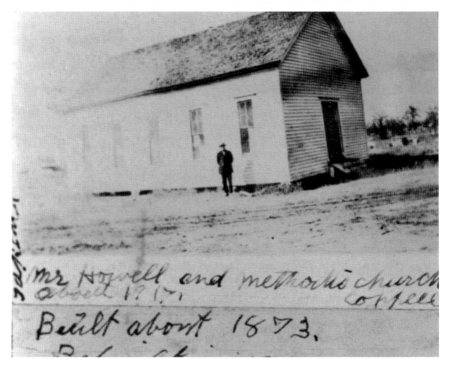

Burrell Howell is pictured here in 1917 at the Methodist church, a community gathering spot built in 1873.

Among the first preachers were Reverend J.B. Bennett and Reverend H.T. Johnson, who later became the superintendent of the Methodist Children's home in Waco. Other early pastors were F.J. Falger, Nathan Higgins, J.F. Short and J.R. Archley. The church had fifteen charter members. Mr. and Mrs. B.B. Howell, Reverend J.B. Bennett, Mr. and Mrs. Erwin Thomas, Mr. and Mrs. Bill Corbin, Sterling Stringfellow, Sallie Stringfellow and Mr. and Mrs. J.M. Stringfellow were among them.

Lumber for the new building was hauled by teams and wagons from sawmills in East Texas by the younger men of the church. The older men remained at home and cut oak and bois d'arc trees for the foundation.

Most social activities were church-related. Popular activities were dinners on the grounds, ice cream socials, box suppers and all-day sing-alongs. The community gathered for Christmas at the church, and Santa brought presents for the children.

On November 11, 1936, a meeting was held to discuss the need for a new church building. The old structure was past the point of repair, said Eby. It cost about $700, and most of the work and funds were donated by church members. Some of the old lumber and bois d'arc piers were used in the construction of the new church building that still stood in old downtown until the 1900s.

The church's location at the corner of Heartz and Bethel School Road was purchased in 1979. Construction began on the new sanctuary in 1984, which is now the fellowship hall. Later, the old building was named Stringfellow Hall in honor of John and Sarah Jane Stringfellow, among the founders of the early church. The education annex was consecrated on February 26, 1989. The church now also occupies a new sanctuary on Heartz Road.

First Baptist Church Minutes Tell Story

The First Baptist Church of Coppell, Texas, was organized on August 24, 1896, founded before the electric light and horseless carriage, "when women's skirts swept the ground and handle-bar moustaches were a common sight," wrote Theresa Eby. The church was organized by G.O. Key, and the board consisted of the following men from Grapevine: H.H. Morehead, S.F. Murphy, Zeb Jenkins, H.F. Sanders and J.H. Bennett. The original congregation consisted of nineteen members, with the first church roll listing J.B. Harrison, Mrs. N. Harrison, Miss S. Harrison, Tyler

Community Christmas celebrations were held in the Baptist church, built in 1896, because the church had the highest ceiling, accommodating a Christmas tree.

Harrison, T.J. Harrison, Mrs. L. Harrison, Ida Harrison, Nora Harrison, W.O. Harrison, Mrs. L.T. Harrison, Mrs. L.H. Harrison, Mrs. Bust, Mrs. N. Duncan, E. Bowen, Mrs. O.A. Bowen, Mrs. Bickley, B.L. Nicks, Mrs. M. Nicks and E. Parr.

"In conference on Saturday night before the third Lord's day in August [August 29, 1896], the church voted to continue conference at the next regular meeting, which would be Saturday night before the third Lord's day in September, for the purpose of calling a pastor," read old board minutes. "Brother E.M. Wood was called and served as pastor for two years."

T.J. Harrison and O.J. Fuller were the first deacons elected by the church, in 1897. At that time, the members voted to join the Dallas County Association, and in 1898 a representative from the church was sent to the state convention. After the church was formed, records show that on the third weekend, services were held Saturday night, Sunday morning and Sunday night at Cottonwood (Baptist) and at the Methodist church.

The records are not clear as to when the first building was begun, said Eby. The minutes read, "Coppell Baptist Church met in conference Saturday night before the third Sunday in September, 1898…The building committee did not report. There was a storm coming up. Meeting adjourned."

Reverend Wood was followed by Reverend W.W. Scales, who served eleven months. In 1899, a member of the church was excluded from its fellowship. She had been charged and found guilty of heresy, according to church minutes.

In the beginning, the church had county, state and foreign missionaries, supported solely by prayers and offerings. The first collection for missions was taken on June 9, 1900. The amount received was $12.50. In July 1900, Reverend R.B. Morgan was called for half-time service at a salary of $350.00 per year. The first sermon Brother Morgan preached closed with seventeen people joining the church.

In February 1901, Mr. B.L. Nicks was hired as the first janitor. He was paid one dollar per month for his services.

The minutes continue to mention the building and finance committees and call for their reports. Evidently, the church was built as money was received to pay for it, said Eby.

First Baptist Church was dedicated on July 14, 1902, with Dr. George W. Truitt of First Baptist Church in Dallas delivering the dedicatory sermon. Just six months after the dedication of the new building, a storm caused damage and moved the building off its block foundation. The cost of repairs was $30.30.

Frequently mentioned in the old board minutes was the discipline committee. In August 1902, a "brother" was excluded on the charge of contempt of the church.

"No conference in September or October on account of rain," records stated. At a cost of $3.60, the congregation received thirty new songbooks in 1907. Acetylene gas lamps were installed in the church and the aisles carpeted in 1909. The carpeting cost $14.85 and the lamps $7.50. In December 1909, the church voted to send money to the County Missionary Association to help buy the county missionary a horse for use in his work.

On September 23, 1916, the church extended the position of pastor from fourth-time to half-time and called Brother I.M. Phillips. Sunday school officers for the year 1916 were E.C. Gentry (superintendent), Jess Wilkingham (assistant superintendent), Sam Duncan (secretary), E.W. Parr (treasurer), Lena Harrison (organist) and Evalena Sanders (assistant organist).

In 1926, a ladies organization began. Minutes stated that a "motion [was] made and seconded that church express their approval of the move the Ladies Aid are taking toward repairing the church house."

Winter of 1929 found the church in need of coal, and the stove pipe was said to be a firetrap. Mr. C.P. Thomas made the motion that coal and new

pipe be bought. Mr. E.C. Gentry was elected to select the pipe and bring out the coal. Several window lights were out, and "Mrs. Parr said the Ladies Aid would see to this matter," said the minutes.

Within the membership was a young boy who seemed outstanding, Eby wrote. A license to preach was granted Dale Moody when he was seventeen years old. Two years later, on May 14, 1933, he was ordained as a minister. Two months later, he started his official ministry at the church at a salary of fifteen dollars per month. Due to his young age, it was understood his position was temporary. In October of that year, Reverend L.V. Fortenberry was called to service.

Records indicate the Great Depression was felt in Coppell. A new building was needed and several times a building committee was elected, but plans were not carried out. The congregation kept making repairs, and in 1942 a new oil stove was purchased to replace the old coal stove.

That same year, the community faced an election to prohibit the sale of beer. Mr. A.N. Corbin was authorized to take $3.25 from the treasury to pay for literature to be passed from door to door in the interest of forbidding the sale of beer. The campaign was successful.

Old-timers reported activities such as a Fourth of July Homecoming Day and "big dinner," held under the old Baptist church arbor in downtown. Food was brought in trunks and old washtubs. "Dressy clothes were worn, with little girls in white dresses and socks and black patent leather shoes. Those in attendance gave Christian testimony in the afternoon in the Baptist Church. Men wore blue serge suits, black Stetson hats, black Florsheim shoes, and white shirts and ties," wrote one unidentified church member.

FIRST ASSEMBLY ACQUIRES LAND

In June 1954, Coppell First Assembly of God held its first service in an old drugstore owned by Hubert Kirkland at the intersection of Coppell and Bethel Roads. This was the culmination of an effort by Martha Thompson to have a local Assembly of God church in Coppell, according to church members.

In the fall of 1954, A.L. Perry became the church's first pastor. Pastor Perry, along with Charles Irby, a member of the church, began looking for a new building to accommodate the growing congregation. They located and purchased a six-room house with an acre of land at the corner of Bethel and

Ester Roads, the current location of Hard Eight restaurant. Two rooms of the house were converted into an auditorium, with the remainder serving as Sunday school rooms.

In 1964, Reverend C.A. McBride was nominated and unanimously chosen by the members to be the new pastor. "I didn't start the church," McBride said.

> *There were a few people there when I came. We met in the old drugstore. They met in that building some and then where the old church was there on the corner. There used to be an old, old house there. The church was built out of the lumber of that old house. And, they told me that the only way they could get that, because there were some old timers that said "Now, look, we don't need you here. We've got a Baptist. We've got a Methodist. We sure don't need an Assembly of God Church. That's enough for no more people than we've got here." But the land was eventually sold to the church.*

In 1974, the church bought three acres on Heartz Road and began to build its third building. Men of the church donated their time and labor to complete the new building. "We moved in on Sunday, May 18th, of '76. We had a parade that Sunday from the old church to the new." Later, the church obtained more land around it. Local businessman Don Carter donated several acres adjacent to the new building. Additions continued to be made to the church, including the C.A. McBride Family Life Center, which featured a full gymnasium, kitchen, classrooms and a fellowship hall. In 1997, additional building space was added to accommodate the music and Christian education departments. McBride retired from Coppell First Assembly of God on June 6, 1999, after serving almost thirty-five years. After McBride, the board of deacons called Reverend Rodney Collver as pastor in November 1999. In 2003, after a major renovation of the facilities, the church changed its name to Living Hope Church.

Many other churches have been added to the Coppell community since the early days.

Four Historic Cemeteries Trace Residents' Roots

Bethel Cemetery Was the Only Public Cemetery

Historic Bethel Cemetery on Coppell's east side, formerly called Sands Cemetery, holds much early history even though only two grave markers remain. At one time, the cemetery contained hundreds of graves, including four persons who had been hanged, as well as reportedly a section for slaves. For years, the old cemetery, located on Moore Road at its intersection with Christi Lane, had become overgrown. Gravestones were overturned and broken. According to old-timers, during one period, gravestones were gathered into a pile and destroyed. In the mid-1980s, even more graves were almost lost to new development. Coppell later created another public cemetery, Rolling Oaks, on the city's west side.

James Parrish, who received the first land grant in the Coppell area, set aside a portion of his land for a cemetery in the Bethel community for travelers passing by in wagon trains, as well as friends and family. Begun in the early 1850s, the cemetery was first called Sands Cemetery, and the name was changed to Bethel by 1885. Freewill Baptist Church, organized in 1885, was built near the cemetery, wrote Margaret Ann Thetford, after research for a *Dallas Morning News* article. The church later became Bethel Church.

According to Thetford, between two and three hundred people were buried in Bethel Cemetery. In 1988, Ruby Hood McDowell, a Coppell native already in her eighties who had numerous family members buried

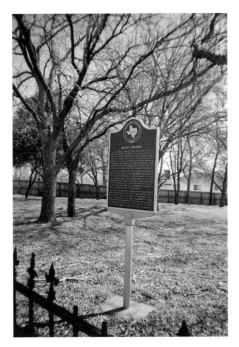

Bethel Cemetery, with only two remaining gravestones, holds the graves of several hundred settlers, Civil War veterans and even slaves, according to old-timers.

in Bethel Cemetery, said there were at least three hundred graves in the cemetery. Undoubtedly, many unmarked graves still exist outside the boundaries of today's stately cemetery gates. The only remaining markers are those of Oda Kirby, who died at birth in 1909, and Ervin Wickersham, who died in 1915 at the age of five.

Civil War history abounds in the old cemetery. Josiah Record, who lived in the Bethel community near the Parrish family, was lynched because of his opposition to the Civil War. John Record, his young son, vowed that he would find and kill those who lynched his father, according to research by the late William T. "Bill" Cozby, historian and former mayor of Coppell. A few years later, John Record killed a man named Holland, thought to be a member of the Holland family who patented surveys in the northwest part of Coppell. John was not prosecuted because officials were pro-Union men, said Cozby.

In 1868, John Record, his twelve-year-old brother Otis, another Texas boy and two boys from Illinois were working cattle in Hackberry Creek, about three miles southeast of Coppell. A posse rode up and hanged four of them, including John. One of them escaped and spent the night at George Corbin's house, halfway between Coppell and Grapevine. The boy, whose last name was Hedrick, left the next day for Graham, Texas, according to Cozby. The Parrish family buried the four men in Bethel Cemetery. None of the men's graves is marked today.

Cozby wrote, "For some reason early Dallas County historians chose not to write about this lynching; however, it was mentioned in early Denton County History in a letter written by a Denton County resident," dated August 29, 1869. It read: "Ku Klux or vigilantes have been working down in Dallas County, if the report is correct and I suppose it is. On the third

of this month, five men and a boy were found hung on Hackberry Creek on Grapevine Prairie and two about three miles away. Men named James, Akers and Record and his young brother, a boy about 15 years old, were all found hanging on a pole stuck in the fork of a tree and then propped up with two forks like you were going to hang a hog."

Bill Cozby wrote that his grandparents James Penson Howell and Melinda Pemberton Howell were buried in Bethel Cemetery, explaining that "their graves are lost." This led to Cozby's interest in restoring the cemetery. In the late 1970s, Bill Cozby, newspaper reporter Jean Murph and librarian Judi Biggerstaff began a restoration effort. A fund was started, and work began to clean the site. As residential development moved into the area, the group sought the help of city leaders, who halted construction in 1985. The Army Corps of Engineers surveyed the site and discovered at least one grave and skull far outside what was then the boundary. An additional 13,431 square feet of land was added to the existing 8,464-square-foot cemetery, bringing the site to nearly half an acre, according to Lou Duggan, who was mayor at the time.

In 1979, Cozby contacted Clifton D. Harrison, a historian and Coppell native, who researched the cemetery and compiled over three hundred pages of information in a scrapbook reproduced for the Coppell Public Library. In 1989, research was completed and a Texas State Historical marker placed at the site and dedicated. Today, a wrought-iron archway stands over the cemetery entrance, and a matching fence surrounds the property.

According to very incomplete records, the following persons or families are buried in Bethel Cemetery: Akers (hanged, September 3, 1869); Barkley (hanged, 1869); Berry (flu, following World War I, 1918); Boyd (a child traveling with his family in a wagon train died from a snakebite, 1870); Muriel Burden, 1909, and four other Burden family members; Greer (hanged, 1869); Joshua Hill, 1859, and Elizabeth; Mosey Hixon; Ida and Joseph Hood; James Penson Howell, Melinda, and son John; William James (hanged, 1869); Oda Kirby (1909, born and died on the same day); Martha Kirby; three Ladd family members; Peter Parkey (Confederate veteran from Tennessee); Minnie Pugh; John (Confederate veteran), Otis and Silas Record (all hanged in 1869); Russell (hanged, 1869); five Thomas family members; three Thomasson family members; John Wayne Ward; and Ervin Wickersham (in one of two remaining marked graves, born October 11, 1910, died December 5, 1915).

Bullock Cemetery Was Created at Child's Death

Coppell's forefathers had a plan for their families as they reached the other side of life. Four landowning families set aside acreage for family cemeteries that today bear the names Bullock, Stringfellow-Moore and Parrish, in addition to the public cemetery, Bethel.

Often, a family cemetery was created out of need. In 1866, Washington Curtis Bullock acquired 480 acres of land on Coppell's west side, north of Bethel School Road and west of South Denton Tap Road. In 1869, the youngest of his nine children, Julia Caroline, died at the age of three, and the cemetery began with her burial. Bullock set aside half an acre for the cemetery at the back of his home. Today, the cemetery is reflected on a deed as Historic Bullock Cemetery, with a size of 0.245 acre. Bullock raised stock on the land and kept 125 acres under cultivation, according to family members. He built what is thought to be the first brick house in Dallas County on the tract, making handmade bricks at the creek in back.

The Bullock Cemetery contains the burials of about forty members of Bullock's extended family and their descendants, according to a historical marker at the cemetery. Among those buried there—in addition to Bullock, who died in 1889, and his wife, Caroline, who died in 1899—are Burrell B. Howell, a Confederate Civil War veteran, and William T. Cozby, one of Coppell's early mayors and a World War II veteran. Also buried there is Bill Kirkland, a World War II veteran, and members of his family. Among others buried in the cemetery are the following family names: Plumlee, Cole, McGee, Oliphant, Kinkle, Harrison, Hyder and Dunagan, according to information gathered by William T. Cozby. Some of the names are not found on stones.

According to the marker, the Bullock heirs sold the remainder of the original acreage in 1902 to J.R. Powers and set aside the cemetery in the transaction. The land at the northwest corner of West Bethel School and Denton Tap was subsequently bought by Walter Thweatt, grandfather of J.C. Thweatt, who owned the land at his death in 2005. The property has now been developed as a residential subdivision. Ingress and egress to the cemetery were provided during the sale of the land.

Stringfellow/Moore Cemetery Also Started with Infant Death

An infant's death appears to have initiated another Coppell cemetery. One of three cemeteries on Coppell's east side, Stringfellow Cemetery is nestled on a hill behind two large homes on Carter Circle, off Moore Road. Barely visible from the road, the small cemetery is accessed by an easement between the homes. Stringfellow Cemetery, called Moore by some because Moore family members are also buried there, began as early as 1882 with the burial of the infant daughter of A.T. and A.J. Crow, according to historical records. The unnamed child was born on July 12, 1882, and died on July 30, 1882. She was the first of many infant and child burials in the cemetery.

Three other Crow children are buried there, none of them living past the age of six, according to records. The first of the four Crow children was born in 1882. Four of them were buried within nine years, by the year 1891. In addition to the first infant, S.R. Crow lived to be five; Gracie and Bessie Crow lived to the age of six. No information about the cause of death is available.

Another infant, Mary R. Bennett, daughter of Jil and M.A. Bennett, was born on March 14, 1892, and died ten days later on March 24, 1892. Mary A. Bennett, mother of the infant and wife of Jil, is also buried in the cemetery. James T. Benson, son of W.D. and Lora Benson, was born on January 23, 1903, and died on August 6, 1904. A large granite stone with no writing marks the grave, according to records.

Other graves read like an early Coppell history roster: Amanda E. Stringfellow, wife of T.J., no dates given; Laura Ollie Thweatt, wife of W.K., born in 1884, died in 1900; George Parrish, born in 1882, died in 1947; Harry C. Moore, born in 1856, died in 1948; and his wife, Mary O. Moore, born in 1861, buried in 1922. Also buried in the cemetery are two members of the Thom family, Godfrey and Auguste Wilhelmine Dollgener; two members of the Garrett family, Fred and Florence; and two members of the Warren family, Harry Lee and Edna. Additional burials have occurred but were not included in the records, according to family members.

Parrish Cemetery Holds First Settler

Even though James Parrish had set aside land for Sands (Bethel) Cemetery for passersby, family and friends, when he died, his wife, Eliza, saved a

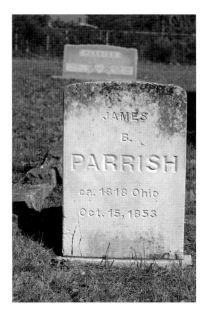

James Parrish's grave, in Parrish Cemetery, indicates his date of death, 1853.

separate half acre of family land for a family burial ground. James Parrish, who received the first area land grant and settled on the land in 1853, died less than a year later. Eliza buried him at the new family cemetery.

Today, Parrish Family Cemetery sits in a neighborhood in the 700 block of Cardinal Lane, east of Moore Road. More than thirty-five members of the Parrish family have been buried there, according to the historical marker at the site. With several burials since the marker was installed, family members believe that between thirty-five and fifty persons are buried in the cemetery.

After her husband's death, Eliza Record Parrish married Henry Parrish, her husband's brother. They and six of their seven children and their descendants are buried in Parrish Family Cemetery. The earliest burial was James Parrish, born in 1820 and died in 1853. Other members of the Parrish family were James A., Richard, H.S., Mary, Almeda, Joseph, Cornelius, James Anderson, Jessie, M.H. and a grave without a name. The historical marker states that Elizabeth's father, Josiah Record, and two of her brothers, John and Silas Record, are buried there. Other family names in Parrish Family Cemetery are Griner, Byers, Askey, Bennett, Record, Petty, Moore and Crow. According to records, many dates on gravestones are known to be incorrect.

Railroad, Roads Put Settlement on the Map

I n 1887, work on the railroad began in the Coppell area. By 1889, one could travel between Gibbs and Grapevine on the railroad, according to local records. In 1889, the railroad changed the name of its Gibbs rail station to Coppell, named after purchasing partner George Coppell.

The town was notified to change the name because there was another Texas town or post office with the name Gibbs, according to early records. The town changed its name to Coppell also, as detailed earlier in the book.

In addition to its service for loading cotton and other crops and unloading supplies and mail, the depot was a favorite gathering spot in town. Residents described the excitement of sitting and waiting for the train to arrive. The original big depot was a long building, heavy and painted yellow, recalled Mildred Cherry at ninety. "It had benches in a big room. Years after I left, I heard they had sold the depot and moved it away." She recalled "having to flag the train down with an old electric lantern." A round-trip ticket on the "Katy" from Coppell to the state fair cost $1.25.

Mishaps Follow Railroad

With the advent of the railroad, numerous accidents and one murder were recorded in issues of the *Dallas Morning News*. In one of the most unusual events, described in a December 12, 1905 article titled, "Boys Shoot Through

Outhouse Door, Striking Railroad Man," a man, James C. Whitaker, a section foreman on the Cotton Belt at Coppell, Texas "died here [Texarkana] in a sanitarium last night." He had been taken there four weeks before for treatment of a bullet wound to the knee.

According to the *News*, Whitaker's wound "was inflicted by young men who passed the section house and fired at the closed door of the outhouse in which he was at the time." Whitaker's leg was amputated, "but the patient did not recover from the shock of the operation." The fifty-six-year-old man was survived by his wife, who had accompanied him to the sanitarium. His remains were sent to Coppell for burial, according to the article.

A May 15, 1907 article, titled "Train Runs Down Man," chronicles the injury of a man named Santis from Smithfield who

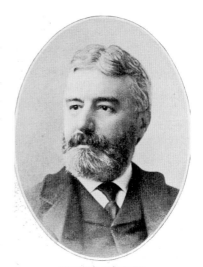

GEORGE COPPELL
MAITLAND, COPPELL & CO.
BANKERS AND FOREIGN MERCHANTS

First the depot's name and then the town's name were changed to Coppell, renamed after George Coppell, a railroad executive.

was "run down by the Cotton Belt train…and seriously although probably not fatally injured." The man was taken to Fort Worth to Dr. Thompson's sanitarium, where his leg was amputated, according to the brief article.

Another article, year unknown, describes an additional injury on the Cotton Belt line at Coppell, noting that "David Henderson, a 10-year-old negro boy, had his leg crushed from the knee to the ankle and hanging on merely by the tendon. He was brought in [to Dallas] on the Cotton Belt at 11:30 last night and sent to City Hospital." The boy worked for the circus "but got left by the show train and was trying to catch up with it by stealing rides on freight trains. At 4:30 yesterday, he attempted to get a hold on a through freight train that came along on the Frisco. He failed to get a hold and fell with his left leg across the rail."

In a December 1917 edition of the *Dallas Morning News*, John Cribbs was charged by complaint with the murder of a railroad foreman in a dispute. Cribbs was in court three times, according to the article, first turning himself in on an assault charge, which was later changed to murder when Wells died. Wells was survived by his wife and several children in Coppell. Bail for Cribbs was set at $3,000.

The old depot on far South Coppell Road was first called Gibbs Station, then Coppell.

A Cotton Belt train flies by on an overpass on the south end of Grapevine Springs Park, as ladies in long dresses visit.

BY 1919 ROADS RADIATE FROM DALLAS IN TEN DIRECTIONS, INCLUDING COPPELL ROAD

On April 1, 1903, the *Dallas Morning News* reported that a Dallas County road construction bond project passed with a vote of 1,668 for and 1,125 against. Reflecting an independent voting spirit, Coppell cast only 40 votes, with 20 voting for the road bond and 20 voting against. The article did not give details about the project.

In 1905, Dallas County approved a road bond project for eight roads from Dallas to the county line. County engineers' specifications called for improvement of four "cardinal" roads, with costs between $12,000 and $24,000, and four intermediate roads at greater costs. In District 4, a road then called Coppell Road, which extended from today's South Belt Line Road all the way to Dallas, had a cost of $42,000. Garland Road was also

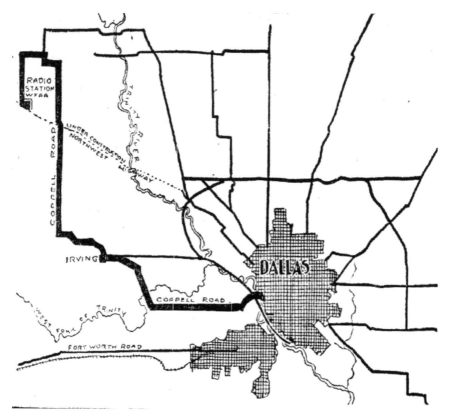

A hand-drawn map reflecting early roads surrounding Coppell.

allocated $42,000. "Eighty percent of the $500,000 bond is to be expended," the article said.

A June 22, 1906 article described the contract to build the road from Dallas to Coppell: "The contract for two miles of the cardinal road leading from Coppell to Dallas has been taken by J. Tyler Harrison Bros. (Coppell), and J.R. Duncan. Work on said road has begun with a good crew of hands and will be rushed right through. Another article describes Coppell Road receiving bridge repair bond dollars, among 16 bridge bond projects. Coppell received $500 for each of two bridges."

In 1919, Dallas County proposed construction of 182 miles of highway radiating from downtown Dallas in 10 directions. One of them was Coppell Road, which traveled "from [downtown] Dallas west via Irving to Sowers, thence north to Coppell to the County line, 25.70 miles in length." An early county map reflects this road. The county employed Nagle, Witt and Rollins as engineers for the project. On May 24, 1919, $6.5 million in bonds was approved for the roads.

A road originally called the Belt Line was also approved to connect the whole new road system, three to five miles from the Dallas County Line. According to the article, the Belt Line would be "somewhere around 45 miles long" and the estimated cost $1 million.

Coppell Road was to be cement from Dallas to Sowers, then penetration macadam and then gravel from Coppell to the county line. In the project, materials for Preston Road were penetration macadam. The roads were built in 1920, according to the article.

Hard Times: The 1920s

Beginning around 1916, temperance, submission and Prohibition became issues of the day in Coppell, along with public referendums on liquor. Coppell residents voted to exercise their local option "for" prohibition. The vote was sixty-nine for and twenty-eight against. In 1919, the Eighteenth Amendment to the U.S. Constitution passed the act of Prohibition, which made consumption and even possession of alcohol illegal nationwide.

This was the setting as 1920 started a new decade in Coppell history. Soon to become known as the "Roaring Twenties," it was the decade of the Model T Ford, the five-dollar workday, the first transatlantic flight and movies. It began as women received the right to vote under the Nineteenth Amendment. Women of the day wore the new "flapper" style of clothing, took the same jobs as men and fought for laws against inequality.

As women embraced new ideas, Henry Ford's Model T automobile was transforming the way people traveled. Soon more roads were needed to support the public's quest for increased mobility. Coppell's days of rural isolation were quickly disappearing, and numerous roads were built, widened and improved during the decade.

"The post office and general store at Coppell, operated by Mrs. Minnie McGee, will be moved back eight feet from its present property line to make room for the right of way of the new paved road to the Dallas pike on which work will begin soon," an August 27, 1925 *Dallas Morning News* article stated. "County engineers just completed arrangements whereby Mrs. McGee will give the eight feet off the store front and along 150 feet of her home site

Automobiles began to make an appearance in the 1920s.

which adjoins. In this manner the right of way for the road will be widened to sixty feet. The road already has been bedded and surfacing will begin soon, the county engineers assured the postmistress. The new road will be a part of the county belt system." In addition, Belt Line Road from Dallas to the county line was asphalted. Sections of Coppell Road, which, in those days, ran all the way to Dallas, were graveled. A new 8.8-mile section of Belt Line Road between Carrollton and Coppell was constructed at a cost of $48,000.

Cotton crops prospered, and Coppell of the 1920s opened its first bank—the Citizen's Bank of Coppell. Someone tried to rob it in 1923, yet according to reports by deputy sheriffs, they were not very good at it. On a Saturday night in February, "Robbers entered the bank through a hole in the wall and attempted to open the vault," the *Dallas Morning News* reported. "About $9.70 in currency and two pistols were reported taken from the bank office. A deep hole was chiseled in the vault near the knob," the officers said. They declared the robbery was the "work of amateurs." A little more than a year later, in March 1924, the bank was declared insolvent. "Weldon had nine dollars in the bank and lost it all," resident Zelma Plumlee said of her husband. The bank's president, Elmer Adams, was indicted on two counts of "receiving deposits after the insolvency of the bank."

However, in one regard, the 1920s in Coppell were no different than earlier decades. Without a fire department, the town was vulnerable to an occasional fire. In 1927, fire of an unknown origin "destroyed the ground stock of merchandise owned by J.W. Stringfellow," the November 12 *Dallas Morning News* reported. "Three brick buildings which housed the stock were also damaged."

In March 1928, Stringfellow opened a new brick store. Of the damaged brick buildings, the east half of one was rebuilt, with the west half to be rebuilt later. "The owner will operate one of the stores as a general merchandise establishment and the other as a feed store," said the *News*.

Perhaps one of the most significant events to affect Coppell's destiny occurred late in the decade, as Coppell residents moved to consolidate the town's education system into one district. Had this not occurred, the education of area students could have become annexed as Carrollton or Grapevine's responsibility.

In January 1929, the new Coppell School, with more than 160 students, temporarily closed. "With more than 50 percent of its pupils ill of influenza, the school at Coppell has closed for the remainder of this week," reported the *News*.

Later, the stock market crashed. By mid-October, stocks lost billions of dollars within a week. Cotton futures, Coppell's principal crop, fell $1.00 to a low of $1.60 per bale. And Coppell, too, slipped into the Great Depression.

Thus, the Roaring Twenties, a decade that opened with so much promise of mobility, growth and prosperity for Coppell, ended in uncertainty and despair.

13

THE GREAT DEPRESSION: THE 1930s

A fifty-year history of growing cotton had made it the chief crop in the state and now, with its decline, the chief economic problem for the Coppell farmer. Drought hit Texas. A dry, hot wind created a "dust bowl" so thick that it blackened skies even during daylight.

Years later, Coppell resident Howard Elgie "Bert" Parrish shared his memories of this period with his wife, Wanda Parrish Blair, for a memoir she titled *Coppell through the Eyes of a Kid*. "Some days the sky would be black, as the winds swirled through the plowed fields, making clouds of dust that covered everything and us," Parrish said.

As the thin layer of topsoil continued to blow away, farm failures and foreclosures became prevalent.

"My brown horse-mule was being loaded into the truck driven by a big man in uniform," Parrish told Blair. "He had a gun strapped on his belt. Mama held our newest baby and cried as our beautiful, fawn-colored Jersey cow was loaded next. Another truck held Papa's farm machinery with our wagon tied behind it. Mama walked behind the county sheriff's trucks as dust billowed around them. When the dust cleared, there sat Mama holding the baby in a rocking motion and crying: 'I hate this Depression. I hate it. I hate them for taking everything we have to make a living!' Papa came and gently lifted them from the ground. We all walked slowly back to the old farmhouse. Papa was a share cropper on land at Coppell, Texas, that had belonged to his family before the awful times came. I was born on that farm. So were my brother, sister and the baby."

Farm foreclosures rose to new highs. The five-year period ending in 1932 saw almost 10 percent of the nation's farms lost. Max Agress, director of Texas Potash Corporation, told the *Dallas Morning News* in February 1933:

> *A study of the ownership and financing of the farm will reveal that by far more than one half of the farms of the United States are to all intents and purposes owned by those who loaned money and took land as security. I have not made an accurate survey of the actual amount which the farms of the United States are now mortgaged, but it is a safe estimate that over 50 per cent of the farms now owe more per acre than the present total value of the land.*

"Five hundred Texas farms going cheap," a *News* headline read in February 1933. As a result, the government intervened and began paying farmers cash to keep them from losing their farms. Cash was a short-term answer as the government began advocating a more diverse land use.

"We raised our food," said Zelma Plumlee. She lived in Coppell, having arrived at age nine in 1925. "We grew vegetables in gardens; we raised hogs and chickens. That's the way life was. We never knew there was a depression going on. Nobody had money. We were all alike, so we never knew the difference."

With the demise of cotton prices, Coppell farmers began to reduce cotton acreages, raise chickens and move into the dairy business. Milk, butter and eggs were considered more reliable sources of income. "There were no jobs out here," Coppell farmer John Burns said. "We had farms, and you had to make it off the land."

Coppell's J. Walter Thweatt chaired a committee of farmers in support of the federal government's cotton acreage–reduction program. Farmers Willard Good and J.F. Willingham were also on the committee. A meeting was held at a local church, and 250 people attended. As a result of such meetings, an estimated 3,000 Dallas County cotton farmers signed contracts in 1934 to reduce cotton acreage by approximately 48,000 acres. This acreage was instead put into production of dairy products or crops that supported the farmers' livestock.

"People just couldn't make it on cotton anymore," Burns said. "So, they quit growing cotton and began to grow food for their cows."

In spite of its demise, some cotton was still grown in Coppell for many more years. In August 1936, the *News* reported that J.D. Ratliff brought in Coppell's first bale of cotton for the season. The Coppell Gin Company logged it as weighing 1,460 pounds as seed cotton and ginning out at 585 pounds. Yet drought was not to be denied its relentless attack on crops.

A drawing of downtown Coppell businesses and residences circa 1930.

Within four days, Texas farmers looked "on whole rows of cotton devastated by ten days of scorching heat and were unable to estimate what their loss would be."

By 1939, many Coppell farmers had converted a portion of their cotton acreage into dairy farms and other uses. Family names such as Thweatt, Lesley, Caldwell, Dobeka, MacDonald, Johnson, Cabell, Marcom, Burns, Hudnall, Wheeler and Harrington were part of the dairy history of the community. "There were eleven dairies along Sandy Lake Road," Burns said. "People went to Grapevine, Lewisvill, or Carrollton and traded eggs, butter, chickens and produce to live. To make any money you had to make something to sell in Dallas. So, I raised me a herd of milk cows and went into the dairy business. For twelve years I hauled milk to Dallas to make a living."

WPA Comes to Town

During Coppell's evolution from cotton to dairy farms, a new federal jobs program had a major impact on the small, agricultural community. President Franklin Delano Roosevelt created, by executive order, the Works Progress Administration (WPA) in 1935 to bring economic and job relief to a nation in crisis and despair.

In Coppell, the WPA began work in November 1936 on Grapevine Springs Park, the historic site of Sam Houston's attempt to negotiate a peace treaty with Indian tribes in 1843. "During the work, one of the town men dug up a dinosaur skeleton, which is on exhibit at Southern Methodist University," resident Clayta Harwell wrote years later.

"Hundreds of people came for the park dedication service," Harwell wrote. "I was present for the dedication ceremony. Even [the son of the late Governor Sam Houston, Temple Houston] was present. A ball park was on the south side of the park, and the day closed with a baseball game, which Coppell won. [Temple Houston] threw the first ball."

"We knew Jeff Thweatt and Ab Miller donated the land for the park," said Zelma Plumlee, who was twenty at the time. "Everybody in town knew about the construction and the land's historic connection to Sam Houston."

According to WPA documents, work on the park cost $25,000 and required five months to complete. Ninety men were employed on the project. Construction work included an 1,800-foot retaining wall of native rock; 2,500 feet of gravel walks; stone entry columns; three footbridges and a dam; twenty picnic tables; thirteen benches; and landscaping with trees, plants and shrubs.

In 1936, the Works Progress Administration constructed stone walls, columns and other structures at Grapevine Springs Park; roads were begun earlier.

However, the WPA was in Coppell on another project months before work on the park was approved. "Most people think of the WPA in regard to work they did at Grapevine Springs Park," said Johnny Dobecka, who was eighteen years old during the project, "but I remember them for a different reason. They actually came into Coppell in the middle '30s. The reason I remember it so well is because they kept their horses, mules and wagons at our old home place. There was a hill on Ledbetter Road right next to our house. They cut that whole hill down with pick and shovels, with pick and shovels. It took quite a while. They had five or six wagons, which they used to haul dirt, sand and rock from that hill down to a low spot where the road crossed the river. They dumped their loads there and raised the road." In

Grapevine Springs Park and the WPA stone columns at the South Coppell Road entrance were a gathering spot for all ages.

addition, portions of Belt Line Road between Coppell and Carrollton were built by WPA labor. In 1939 alone, an estimated ninety-seven miles of road within Dallas County were built by WPA crews. This work employed an estimated 1,500 men for twelve months.

"A man from Coppell, it was Arthur Hodges, worked for the WPA," said Plumlee. "He got hurt. Something hit him in the eye while he was working, and he lost an eye."

"People couldn't buy groceries without a job," said resident John Burns. "The government put that WPA program in to give people a job. They had to make jobs because people couldn't eat."

"There were about two hundred people in Coppell in June of 1936," Bert Parrish shared in his memoir. "Town was one red brick school house, two white, frame churches, a cotton gin, drug store, picture show, barber shop, grocery store and a tiny U.S. Post Office that seemed to grow out of a giant cottonwood tree. A Coppell treasure sat beside it. The old domino table with wooden benches was a busy place for the farmers, unemployed men and the old men to gather. They played dominoes after breakfast until lunch. Play started again after lunch and afternoon naps until supper time."

THREE DOBECKA BROTHERS MARRY THREE SISTERS

The Dobecka family demonstrated the continuing importance of farming to the Coppell community and the local economy, which depended on farm-related businesses, including cotton gins, dairies, a blacksmith shop, lumberyard, railroad activity and an abundance of good food. At eighty-eight, Johnny Dobecka recalled that his father came to Coppell in 1912 to farm 286 acres along the Elm Fork of the Trinity River, between Carrollton and Coppell, in what is Valley Ranch today. His father farmed cotton, corn, oats and maize. The land was in the river bottom, and once during a period of flooding, the family had to replant cotton three times. They raised cattle and tilled a garden. In 1938, the Trinity River flooded, and Dobecka recalled riding out of the bottom on a wild horse after tending cattle. The family eventually sold the home place to Boots Lesley at eighty dollars per acre, said Dobecka.

Dobecka, whose grandfather emigrated in the 1870s from Moravia, started a trend as a young man. His future wife, Vickie Crevenka, born in 1930,

moved in the 1940s to the Trinity Mills area in Carrollton. They met and married, and then, two of Johnny's brothers married two of Vickie's sisters. After the war, Dobecka worked in various jobs in the Carrollton and Coppell area. He and his brothers entered the grocery business at "Crossroads" (Sandy Lake at Interstate 35) and operated a service station. Soon after, Johnny Dobecka joined the dairy business on the old Dobecka home place, raising fifty head of cattle. The milk was sold to Metzger's Milk Company in Dallas. Located on the north side of East Belt Line Road, north of the railroad, the dairy operated until the 1950s.

The Johnny Dobecka family had six children. To raise their family, the Dobeckas bought three acres along Sandy Lake Road in 1959. They were instrumental in starting the Catholic church in Coppell, and Johnny Dobecka ushered for forty years. Their son, John, served on the city council.

Dobecka recalled all the old "honkytonks" that operated along Sandy Lake Road during the late 1930s. Among them were the Spanish Inn, King Tut's, Do Drop Inn and Elsie's. The bars were gone after 1945, he said, explaining with his dry humor, "Too many Baptists here."

Ottingers Worked on a Coppell Hog Farm

Bobby Ottinger, always one to get out on the ground to show Coppell's history, provided descriptions of early geographical sites and contributed old farm and family memorabilia for a future Coppell museum. He wasn't bothered by getting dirty or wet to show interested parties an old farm or remote creek bed, and he personally rescued a reporter with his cane when she couldn't climb back up the slippery banks of Denton Creek.

Even though Ottinger's family history goes way back (his mother, Eula, was a Holt), Bobby Ottinger described a later activity, hog farming. Hogs were part of almost every early farm, but hog farming as a business did not start until the late 1930s. Ottinger recalled moving to the farm at Sandy Lake and Denton Tap Road at the age of three. After sharecropping on a farm near North Lake, his father started the hog farm for the landowner, Dr. Floyd Norman. The Ottinger home sat near an old windmill, torn down in 1995 to develop a Wendy's restaurant on Denton Tap. The hog farm began with seven brood sows, which had 45 to 50 piglets. Most years, the farm had between 1,300 to 1,800 hogs, said Ottinger, who worked on the farm in his early years. The family bought day-old bread from Mrs. Baird's Bakery to

Johnny Dobecka worked on one of several dairy farms that were established in Coppell.

feed the hogs. Ottinger remembered hauling 150,000 pounds of bread to the hogs, sometimes as many as two loads a day, five days a week.

Butchering a hog for food was a community event, he said. The men killed, slit and strung up the hogs to "bleed," while the women prepared food for the big lunch. Families made cheese from the head, "cracklin' bread" from the cracklins and lye soap from the "lard rendered out of the hog." The Ottinger hogs were sold to Nuhoff's Packing in Dallas and the stockyards in Fort Worth. Ottinger remembers the process of herding hogs for slaughter. At times, the hogs were "so thick we could walk on their backs, which we did many times." The family had a dog that "trained itself to work the hogs just by watching us." The hog farm closed down in 1968, he said, adding, "The city gave us a fit because of the smell, but we were grandfathered." The farm had to meet stringent health standards. Though he believed "it was time" when the farm closed, he said, "Now it's sad." The Coppell hog farm just south of Town Center, where the Tom Thumb store sits today, gave rise to a later community celebration called Pigfest. Another hog farm was located at today's D/FW Airport.

BEER, BURGERS, BRAWLS AND BABES MAKE SANDY LAKE ROAD A DESTINATION

Coppell was still an unincorporated corner of Dallas County when Prohibition was repealed in 1933. Jane Moore researched this era for the *Citizens' Advocate* and reported that before long, Denton Tap and Sandy Lake Roads were the hub of a lawless honkytonk heaven for everyone from college students to bootleggers. Where Frost Bank sits today was a restaurant, watering hole and dance hall called Midway. "Everybody probably within fifty miles knew about Midway," said Bobby Ottinger, whose childhood home was next door to Midway's tree-shaded gravel parking lot. The building sat at an angle, with the front door facing west. The Ottinger house was between there and what is now Wendy's. According to Ottinger, the Midway building and the land, which included a large farm, was owned by the late J.C. Thweatt's grandfather Walter Thweatt.

Dairyman John Burns said some of the old-timers of the day actually referred to the whole area as Midway because it was five miles from the towns of Lewisville, Grapevine and Carrollton. Burns, who lived on Sandy Lake between Moore and Heartz Roads, said college students came in droves from Denton on weekends, making the rounds to all the honkytonks, including two on Denton Tap near the creek and four on Sandy Lake Road. Bootleggers from "dry" Oklahoma also used the area as a hiding place until their midnight runs across the border.

"You couldn't get down Sandy Lake Road," he said.

Famous for its big wooden dance floor that would accommodate twenty-five couples and a fine restaurant that served steak, the Midway also had gas pumps, a meat market and nickel slot machines, according to Ottinger. "There was always somebody coming in and robbing that Midway and getting their slot machines," he said, remembering one night when the family heard people running down Denton Tap and someone yelling, "Stop or I'll shoot," interspersed with gunshots, which were not a particularly uncommon sound. And more than once, the Ottingers woke up to find a drunk passed out on their front porch. There was minimal law enforcement, and even when they were called, there was plenty of time for outlaws to escape before they arrived. "Dad wouldn't let us kids go out at night, because you never knew what was going to happen," Ottinger said, adding that during the day he sometimes played with two boys, Jerald Crow and Richard Ihnfeldt, whose fathers ran the Midway. The boys invited him to lunch in the restaurant a couple of times, and he once took a peek at the dance

floor, which was separate from the eating area. Jerald Crow's father owned the business, and Richard Ihnfeldt's stepfather, Rebel Bragg, managed it, according to Ottinger. Others remember Joe Stout as the primary owner of the business for a number of years.

Mr. W.D. "Ted" Willhoite of Grapevine wrote of visiting Midway during its heyday:

> *In 1934, three couples were married within a period of three months. They were Lamoin Wright and Mattie Mae Lucas, Gordon Tate and Louise Bennett, Ted Willhoite and Wilena Kingston. One night in August, five local gentlemen decided to "chivaree" the newly married men. The five were J.T. Simmons, Lindley Lucas, Harry Wiggins, Bob Lipscomb and J.T. Lucas. The plan was to take the three to Carrollton Dam on Sandy Lake Road. On the way, J.T. Simmons's car died about one mile before reaching Denton Tap Road. After working for some time, they got the car running, but due to the late hour, the chivaree was held at Midway Night Club on the corner of Sandy Lake and Denton Tap Road. Needless to say, some of the group had a little too much to drink. To turn the tables on them, I slipped outside and removed the ignition keys. Later they decided it was time to leave, and then they discovered the keys were missing. After about one hour or so, the keys appeared back in the car. We arrived back home about 2:00 a.m., wives waiting at their front doors. A "dunking" in Elm River at Carrollton Dam was avoided thanks to one "sick" car!*

"All of the people listed above have departed this earth," Willhoite wrote. "I am fortunate to be the only one remaining, but with fond memories. A twist to the story is that the dance hall building where the 'chivaree' took place was purchased about 1940 by Mr. C.S. Toon, a teacher in the Grapevine schools. He moved the building to the southwest corner of College and Dooley in Grapevine, added to it and converted it to a home for his family. On the northwest corner of College and Dooley, four years later in 1944, I built a brick home for my family—once again renewing the memories of the 'chivaree!'"

People who didn't live near the honkytonks enjoyed them much more, including longtime Coppell resident Johnny Dobecka, whose family home was on 386 acres near MacArthur and Belt Line. As a young man, he and his friends visited almost all of Coppell's "joints," including Shot and Elsie's, Spanish Inn, Do Drop Inn, (all located on the south side of Sandy Lake between Denton Tap and Moore Roads) and Dutch's place,

where Herrington's Bait Shop sat by the river before the bridge on the Carrollton border.

"We'd stop and have a beer at each one of them," Dobecka said. "They were all alike, almost." He said Shot and Elsie Crowder lived behind their business, which was a "highfalutin" place. "You didn't go in there and raise hell—they'd kick you out right quick," he said. All the small honkytonks had tables with nickelodeons at each one and iceboxes (cooled with block ice) filled mostly with bottled beer. Most served hamburgers, and there were usually a couple of slot machines and a small area for dancing.

And then there were the "chippies," old slang for prostitutes; just about every honkytonk had some, according to Burns. "They were gals of the night," he said. Not every woman who came out to dance was a chippy, just the ones who got paid to dance with the men and bring in business.

No tale of honkytonks would be complete without characters like Coppell's well-known local businessman Elzie "King" Tut, who ran the Spanish Inn until the owner told him he was drinking too much on the job, wrote Moore. "He just took off his apron and opened up his store," said Burns, who was a frequent customer at King Tut's Grocery Store and Service Station on the north side of Sandy Lake just west of what is now Kroger. Despite Tut's affinity for alcohol, everyone reportedly liked him. His store, which he ran with his wife, Winnie, became a gathering place for the "Sandy Lake bunch," who in other stores sometimes felt like second-class citizens because of where they lived, according to Burns. "Someone would say, 'Oh, you live over with those honkytonks,' and I'd say, 'Yeah, I see the elite of Coppell and Carrollton out there after dark.'"

Bryine Harrington Graham, owner of Herrington's Bait Shop, remembered her uncle George Herrington, who formerly owned the property, telling her about a domino hall with a "still" back in the trees on the north side of Sandy Lake between the bait shop (built in 1952) and what is now MacArthur Boulevard. A white stucco house now sits at that location. Dobecka called it Dutch's place, and Burns called it Herrington's. Herrington rented boats, sold beer and hosted small dice games, but there was no dance floor.

About the only thing known about the two honkytonks located on the west side of Denton Tap near Denton Creek is that John Burns found a man shot dead and slumped over a fence near one of them one day while chasing one of his cows.

Nita Barfknecht Strong also remembered Coppell's honkytonks. She lived on property her grandfather Barkfknecht owned on the north side of

Sandy Lake Road at Heartz Road, "just east of Ottinger's pig farm. Sandy Lake Road at that time was old highway 77," she said. "It turned north and went to Lewisville." Music was an integral part of the honkytonk experience. "If you wanted music, that's where people went to have a good time," Strong said. "We didn't have radios. We only had crystal sets. They had jukeboxes at all of them. My sister and I would dance to a fast waltz called Pony Boy, and everybody would stop and watch us float around the floor. We did the two-step and the waltz. There was country music, of course, but no jitter buggin'. That didn't start 'til the '40s. Mother bought me a pair of shoes from Sears. They were beautiful, but they nearly killed me."

"Elsie's was the elite one," Strong said. "This was where most of the rich people went. It was the nicest one. It was a white-frame, two-story-like house. It was located by itself on the south side of Sandy Lake Road between Heartz and Denton Tap Road. The location and woods made it a beautiful place. The others were just beer joints." "Midway was another one we went to," Strong said. "It was a service station, a small grocery and also a hangout. They had trees around it and we sat outside. There was another one on the southwest corner at Moore Road and Sandy Lake. It was Uncle Ben Thompson's. My sister and I always went on a Saturday night. My mother would buy us a hamburger and a RC Cola. All they had was hamburgers. The kitchen was small. They mostly sold beer; it was a beer joint."

Burns said it wasn't so much the drinking but the rowdiness that caused him to help start a petition to get rid of the honkytonks in the 1940s. "People don't realize how rough it was," Burns said. "It wasn't a fit place to live."

In 1944, residents voted the area dry. Thus, Coppell's honkytonk years came to an abrupt end, as Dobecka learned when he returned from World War II. "I went in the service, and when I came back in 1945, they were gone."

BONNIE AND CLYDE ROAM THE AREA

With the foreclosures, bank failures and unemployment of the early '30s, banks were blamed for "hard times." This, combined with the public's fascination in the '30s for gangster movies, gave rise to the fame of Bonnie and Clyde.

According to a FBI summary on the couple, Bonnie Parker and Clyde Champion Barrow met in Texas in January 1930. "At the time," the report states, "Bonnie was 19 and married to an imprisoned murderer; Clyde was 21 and unmarried. Soon after, he was arrested for a burglary and sent to

jail. He escaped; using a gun Bonnie had smuggled to him, was recaptured, and was sent back to prison. Clyde was paroled in February 1932, rejoined Bonnie, and resumed a life of crime."

They were wanted from Iowa to Texas. From 1930 until their deaths in May 1934, the FBI stated that Bonnie and Clyde committed thirteen murders, numerous robberies and several burglaries. *Dallas Morning News* reports from those years put the couple in the North Texas area frequently during their crime spree. "Twelve murders in two years," the *News* reported on May 24, 1934. "That is the record of the vicious pack led by the slight, dapper Clyde Barrow and his cigar-smoking woman companion Bonnie Parker. In two years the acts of this pair and their various associates have surpassed by far the crimes of Oklahoma's notorious Pretty Boy Floyd."

"Barrow never remained near the scene of one of his crimes. Driving at seventy or eighty miles an hour in stolen cars, always prepared to shoot with machine guns, pistols, and shot guns, Clyde Barrow became one of the most dangerous criminals in the history of the Southwest...So, Clyde Barrow became the Middle West's Public Enemy No. 1. The United States Government, recognizing Barrow's menace, joined hands with the various States in what has been called America's mightiest man hunt." Historical accounts indicate the "manhunt" for Bonnie and Clyde was a game of cat and mouse—seen here today, there tomorrow, elsewhere next week. However, both Barrow and Parker had ties to the area and knew Dallas and Tarrant County well. Barrow's mother owned a filling station in Dallas. Parker had been a waitress in a Dallas café. The *News* reported later that Barrow used his mother's filling station as a means by which gang members could contact him.

Did Bonnie and Clyde stop in the Coppell area? A bank robbery near Fort Worth in early 1933 placed Barrow in the area. And by April, Bonnie and Clyde were reported on a crime rampage spreading across Oklahoma, North Texas and Louisiana. Then, in November 1933, a deputy constable assigned to Carrollton was driving to Grapevine when he encountered a drunken couple he officially reported as being Bonnie and Clyde. The constable was unarmed and did not pursue them.

Bonnie and Clyde were reported again in rural Dallas County, this time just outside Irving between January 12 and 16 in 1934, as later affirmed by Barrow associate James Mullen. Thus, the infamous pair had been officially placed in the Irving-Grapevine-Carrollton area on several occasions.

Were they reported in Coppell? Longtime Coppell resident Erma Ihnfeldt said her husband, Arthur, had seen a man and a woman camped

with their car in the woods at the corner of Denton Tap Road and Sandy Lake Road. The man had a machine gun and shotgun, her husband told her. Seeing the guns scared her husband, she said. Was it Bonnie and Clyde? News accounts listed above certainly placed them within the area.

"Bonnie and Clyde were in Coppell," contended John Burns. "They killed a DPS motorcycle officer. He was the grandson of the man that owned the Wheeler Dairy in northeast Coppell. He saw them on a road on the west side of Coppell. He saw a Ford parked up there on a hill. He drove up there, and they shot him."

The *News* reported the death but placed the crime on a rural road west of Coppell. "On April 1, 1934 Bonnie and Clyde were practicing with their revolvers on a side road...Two Texas Highway Patrolmen, E.B. Wheeler and H.D. Murphy, who approached them were killed."

Also, the *News* reported another crime, although incorrectly spelling Walter Thweatt's name, on April 24, 1933:

> *A small safe containing $1,330 currency was taken by burglars sometime Sunday afternoon from the home of Walter Tweet, dairyman, living one mile north of Coppell, near the northwest border of Dallas County. The burglary was discovered by Mr. Tweet about 5 p.m. He and his wife returned home after having been absent only a few hours. The safe, a small steel box with combination lock, had been standing behind a door in the living room of the house. Apparently the burglars knew of its location as there were no signs of hasty search or disarrangement of any furnishings in the house. Nothing else in the house was molested....Deputies learned Mr. Tweet had been transacting business by cash since before the March banking holiday.*

Is it possible the Thweatt burglary was the work of Bonnie and Clyde? In April 1933, they had been reported in the area. Burglary was certainly one of the gang's callings. The general location of the Thweatt farm—northwest of Coppell—was near the rural area frequented by the two, and some believe the pair had camped just off Sandy Lake Road. Also, as indicated by the *News* report, Thweatt was widely known to have cash.

Was Coppell a footnote of Bonnie and Clyde's four-year reign of crime, or were the rural roads and large groves of live oaks a safe haven for the two when they were in the North Texas area? After the duo's violent end, the remaining gang members implicated in the crime spree were caught and tried in early 1935. Also charged were Clyde Barrow's and Bonnie Parker's mothers. Serving on the jury was T.E. Standifer of Coppell.

MARKED BY LOSS AND SACRIFICE: THE 1940S

Rural Coppell existed in a world of agriculture. Isolated, it was independent of many of the trappings of urban life. There was no broad form of mass communication or reason to have it. Contact with other area towns and cities was made as financially needed. This isolation, self-reliance and independence forged by the Great Depression would soon bond Coppell with the rest of the nation.

War loomed in Europe and the Pacific. Although America was not officially in the war, young men were being asked to register for military service. Draft boards were being created throughout Texas and numbers assigned to young men.

Although Coppell was a remote Dallas County farming area, the coming war and draft touched its families. On October 16, 1940, Coppell School, as precinct 79, registered eighty-four young men, ages twenty-one to thirty-five. In October 1941, nearly two months prior to the Japanese attacks on Pearl Harbor, two Coppell men were called into the army: Ernest Elzworth Gentry, son of Mr. and Mrs. E.G. Gentry, and William H. Kirkland, son of John and Jeanette Kirkland, were told to report for induction. Then, as with every community in America, the news of Pearl Harbor altered the course of numerous Coppell lives. The main source of information was the radio or newspaper.

Coppell teen Nita Barfknecht Strong was thirteen when she heard the news. "My mother and I were getting ready to eat breakfast before going to church. We always had the radio on. The news came over the radio. and

Johnny McCain (married to Dorothy Gentry) served in the U.S. Army Air Corps.

we just couldn't believe it. We didn't know anything about Pearl Harbor, except that it was in Hawaii."

Coppell dairyman John Burns was in his late thirties on that fateful day: "I remember coming home from bird hunting near Bonham with my brother-in-law and heard it on the radio."

Johnny Dobecka was twenty-one years old when the bombs fell on Pearl Harbor. "Me, Mark [Dobecka], my dad and Boots Leslie were playing 42 at my house when we got the news," Dobecka said. "I was drafted a few days later and had to report January 1."

Before long, Coppell men were distinguishing themselves and being recognized in news reports around the world. Some reports brought great pride, others great sadness. In May 1942, navy seaman Alva Allen Harrison was wounded. He was the son of Coppell's A.A. Harrison family.

Also in 1942, Tommie and Jerry Hamm, eighteen-year-old twins from Coppell, enlisted to become part of the U.S. Army Air Forces technical crews. The twins had gone to an aircraft exhibit situated at Elm and Stone in Dallas at which five additional pairs of twins had also enlisted. Six pairs of twins enlisting at the same time was an unusual recruitment, and Coppell's twins made area news.

Lonnie McCord joined the army, received six weeks of training and was sent to Europe. Harold Arnesmon, husband of Corrine Gentry, also served. In April 1943, another Gentry enlisted in the U.S. Army Air Corps. Lieutenant Clyde M. Gentry, cousin to Elzworth Gentry, received his pilot's wings in 1944. Coppell parents were Mr. and Mrs. J.E. Gentry.

During 1943, Gentry became a sergeant in the U.S. Army Air Forces. After graduation from Carrollton High School in June 1943, Bennie L. Harn joined the U.S. Navy. His parents were Mr. and Mrs. Elmer Harn of Coppell. Another Kirkland son, James S. Kirkland, entered the U.S. Army Air Forces to eventually serve in North Africa. A third brother, Carroll E. Kirkland, entered the army in March 1944.

Claude Thomas became a member of the army's First Cavalry Division and went to the Pacific in 1943. Thomas took part in the invasion of the Admiralties and the Philippines. He was wounded in the left arm by a Japanese sniper.

Seaman First Class George T. Corbin, son of Coppell's Andrew N. Corbin family, received a citation for heroism in late 1943. "According to his commander, Corbin endangered his life by fearless conduct in boarding a barge of ammunition with a fire party," the *Dallas Morning News* reported on January 16, 1944. "The barge was loaded with explosives, including 500-pound bombs. The fire was put out with little damage…destruction of lives, a warship and a floating dock were averted."

As contradictory as it may seem in war, compassion was shown by a Coppell man while in Italy. A war correspondent for the Fifth Army reported the story for the *News* on April 11, 1944:

> *American soldiers can stoically endure almost anything but the sight of hungry Italian children huddled about their chow lines begging for scraps of food from GI mess kits. The emaciated faces of the dirty, ragged youngsters watch anxiously as the scraps are dumped into a large GI can, where they are mixed with hot water and made into a sort of stew that often must be diluted several times in order to provide at least a cupful for the tin cans and buckets the little "Eyeties" hold. That is the scene wherever you find an Army kitchen set up over here. At one Thirty-sixth Division mess, the Americans worked out an equitable system of feeding the "stew" to the Italians, a method that gave the tiny tots an even break with other age groups…custodians of the growing Italian chow huddles, organized them into three lines—one of girls, small boys in another and larger boys in the third. In that order they let them pass by the big GI can where kitchen police dip out their portions.…Private Albert E. Gulden of Coppell, Dallas County, admitted that some of the soldiers make two trips through their chow line to make sure there will be more scraps for the young Italians. "Hungry kids sort of get next to you," he explained.*

Residents also received sad news. Zelma Plumlee, at age ninety, still remembered many of the names: "Carroll Kirkland, Joel Neal and Hiram Shelton were killed in the war. All of them were from Coppell."

"Carroll Kirkland was the first from Coppell to die in the war," said Strong, whose brother, Ralph Barfknecht, also served in the war. "Carrollton High School's 1945 yearbook published a memorial to

Carroll Kirkland, a former graduate. He was killed in Europe on November 26, 1944. I remember that he was so good looking."

Other news reports reflected the horror of war. The son of Mr. and Mrs. Albert H. Starling, Corporal James Starling, served with the Third Marine Division artillery on Iwo Jima. The *Dallas Morning News* described Starling's experience on the island in August 1945:

> *Asleep with three other Marines in a foxhole on a newly-taken position above an airstrip, Starling was awakened at 1 a.m. by a loud scream. One of his companions had just shot a Jap at three-foot range, putting eight .45-calibre pistol bullets into him. The Jap stumbled backward toward a cliff and the Marine sentry started firing at him, but his carbine stuck after one shot and the Jap lobbed a grenade into the foxhole. A fragment just grazed Starling's leg. Three or four Japs were moving around in the darkness and the Marines, out of grenades, threw rocks at them. Next morning the Marines found one of their outfits booby-trapped. After shooting him, the Japs had wired him to a store of ammunition in a hillside cave.*
>
> *Starling's team was relieved next morning, but just after they had boarded a truck for the trip to the rear, the truck backed over a Jap mine and all occupants were thrown to the ground. Then the weary group walked a mile and a half before another truck picked them up.*

Another Coppell resident, Johnny Dobecka, saw much action. Assigned to the Thirty-seventh Infantry Division of the Ohio National Guard, Dobecka was immediately pressed into the war with little training. During his third week of active duty, he was made acting sergeant at the age of twenty-one. He was initially ordered to North Africa but diverted to the Pacific. For more than three years, he served in lead divisions that routed the Japanese from one island to another, eventually winding up in the Philippines. Island names like Fiji, Guadalcanal, Bougainville and New Georgia are just a blur in his memory.

"I was attached to the 145th Division and the First Marine Division all the way through to the Philippines," Dobecka said. "It was hell all the way for about three and a half years. We went from one Pacific island to another. I got hurt in New Georgia."

"We took over a hill where the Japanese were," Dobecka said. "We fought all night long. I was operating a radio. We were in a foxhole that night. At morning there was a sniper in a tree. I think because I had the

radio, he went after me. He got me in the foot two shots. For several days our planes could not get in to get me out, so they took me out by PT boat. I went to Australia to recoup. Later my unit was shipping out to another island so I left Australia on crutches so I could get back to my outfit, back to the First Marines. I don't know how many islands we took. Then, a sniper shot me in the right leg, in the thigh, not too bad. I forget what island that was."

"In the Philippines we were taking over city hall in Manila," Dobecka continued. "Every time we got close they would repel us back. I was a buck sergeant in charge of a company with few men left. They shelled the hell out of us. I was below the stairs of a second story building when shrapnel chewed up my right arm. I ordered up tanks. Three tanks blew the hell out of the place. They sent me to an army hospital in the Philippines."

Dobecka met General Douglas MacArthur "two or three times," possibly even saving the general's life at their first meeting. Dobecka explained that MacArthur was traveling by jeep down a road that was being patrolled by Dobecka and his men. Artillery began shelling the road heavily, and Dobecka said he told the general to "Get the hell out of here!" He didn't know he was talking to General MacArthur at the time. MacArthur later called him to headquarters to explain himself. Dobecka said he told the general that shortly after his jeep left, an artillery shell landed right where his vehicle had been sitting. The general thanked him.

Dobecka met the general again when he was wounded near Manila. According to Dobecka, the general asked him, "How long have you been here, Tex?"

"Too damn long, sir," Dobecka said. When Dobecka was able to rejoin his division, a jeep picked him up and he was shipped back to the States. Dobecka returned to his Coppell home in May 1945. In three and a half years, he had been wounded four times, for which he received a Purple Heart with two clusters.

While news of the war seemed far away for many, the impact at home was also felt. The war required not just men, but money, scrap metal and crops. Coppell donated. Aluminum was in short supply, so drives were conducted in 1941. Coppell School again served as the community's meeting place for the local salvage rally. Again in 1942, a countywide drive was made for scrap metal to be recycled into the war effort. "Old, discarded plows, tractors, binders and other farm implements were targets for the Dallas County farm scrap metal collection drive," the *Dallas Morning News* reported. And, again Coppell gave.

"It was a big deal," said John Burns. "They needed the metal. They tried to get everybody to take it to the railroad depot in Carrollton. Three railroads came through there, so they put it all on a train to ship somewhere."

When war bonds were pledged by county towns, Coppell participated. "Tabulations of the war bond survey in eleven small town districts of Dallas County revealed a total of $20,000 monthly purchases were pledged," the *News* reported in August 1942. Then, again in January 1944, Coppell pledged another $27,000 in bonds.

Shortages of goods were prevalent. Ration books were issued to each family, and coupons for gasoline, sugar and tires became common currency. "They enforced it, too," said Burns. "You couldn't buy anything without a coupon. Sugar was so rationed we had to go to brown sugar. And, you sure couldn't buy a vehicle."

With many young men fighting the war, manual labor was frequently performed by women. They became taxi and streetcar drivers, operated heavy construction machinery, worked in lumber and steel mills, unloaded freight, built dirigibles, made munitions and more.

"Rosie the Riveter" was a popular poster that inspired many American women to support the war effort. One Coppell woman, Nell Gentry Harn, was such an example. "After her husband, Bennie L. Harn, joined the service and went into the war, Nell went to work at North American Aviation," said her daughter-in-law Virginia Harn. "The aircraft she worked on was the P-51, made here in Dallas."

"Nell's maiden name was Nellwyn Gentry," Harn said. "She was the daughter of Ernest and Pearl Gentry of Coppell. Bennie was the son of sharecroppers in Coppell, Lucy and Elmer Harn."

"Nell wore two watches, one on each arm," Virginia Harn said. "On one, she set local time and on the other she set the time where her husband, Bennie, was." Nell Harn was living in Coppell when she passed away in 2001 at the age of seventy-five.

Women also helped the war effort by picking cotton. Cotton was a commodity critically needed for uniforms, coats, bedding and cloth goods in general. J. Frank Wilson owned forty acres of cotton near Coppell in October 1942. The *News* reported his plight: "'Mrs. Wilson, myself and our 10-year old girl tried picking several days ago, but we didn't do much good,' Wilson said. Wilson said he needs pickers badly to gather the rest of the crop in a forty-acre field. He said he has been unable to get help of any kind… ten women employees of the Great National Insurance Company had made arrangements to help."

Nell Gentry Harn supported the war effort by working on P-51s at Fort Worth's North American Aviation plant.

News reports from the war front, notification of casualties, the death of a president, the humor of Jack Benny, the music of Glenn Miller, songs by Bing Crosby and the wit of Bob Hope caused Coppell-area families to turn on their radios, seek out local newspapers, reach out to other families and become part of a larger community. Farmers and ranchers, once isolated, became aware of how outside events shaped their lives.

One news event that pulled Coppell people around their radios was the sudden death of President Franklin Delano Roosevelt in April 1945. Ironically, it was President Roosevelt who had successfully used radio for communication to the American people in his "fireside chats." These radio chats, straight from the White House, were very popular and gave people a sense of hope during difficult times.

"I heard about it on the radio," said Coppell farmer John Burns. "He was down at Warm Springs, Georgia. People just worshipped that guy. I don't know what we would have done without him. He saved the country. The radio covered the funeral."

"Roosevelt's death was big news," said Zelma Plumlee. "Whenever we had a time to sit down and relax, we would turn on the radio."

"I remember that day very well," said Nita Strong. "In those days I had the radio on as long as my mother would let me play it. I loved the music, and we always listened to the news on Sunday. We cried a lot then. It was a hell of a war."

Four months later, Coppell people were given another reason to turn on their radios. On the morning of August 6, 1945, the U.S. Army Air Forces dropped an atomic bomb, "Little Boy," on the city of Hiroshima, Japan, followed three days later by another atomic bomb on Nagasaki.

"When they dropped the bombs, it saved me from being drafted into the war," remembers Burns, who was in his late thirties at the time. "R.B. James, president of my draft board, called me up and said I'd be in the next group drafted. My three younger brothers had already gone. He gave me thirty days to place my cows with someone who would take care of them. Then, they dropped the bombs and that was it."

Change in the '40s also marked the passing of several local citizens. Some had been members of the town's founding families, and their names read like the who's who of Coppell. Moore, Kirkland, Bullock, Standifer and Thweatt—all were noteworthy names from the past.

"Charles Carter Moore, 88, known as Uncle Charlie during many of his fifty-two years as a rancher near Coppell," died in April 1942, reported the *Dallas Morning News*. He moved from Alabama to Texas in 1876. "In 1888 he married Miss Cora McDonald and moved to near Coppell and raised cattle." He had two daughters, one of whom was Mrs. Emmett Coats of Coppell, and two sons, one of which was Tom Moore of Coppell.

John Marion Kirkland, a seventy-six-year-old Coppell farmer, died in August 1943. "Kirkland was born in Madison County, Alabama and came

Coppell veterans returned home.

to Dallas County in 1892," the *Dallas Morning News* obituary stated. He and his wife, Jeannette, had several children living in the Coppell area: W. Hubert Kirkland Sr., James Stringfellow Kirkland, Carroll E. Kirkland, Mrs. W.O. Cooper, Mrs. Harvey D. "Sallie" Brooks, Mrs. Howard Sneed and Miss Jewel "Jackie" Kirkland.

Mrs. Missouri C. Bullock settled in Coppell in 1870 at the age of five. She married George Thomas Bullock in 1883. The *Dallas Morning News* recognized her as a seventy-five-year-resident of Dallas County. She died in October 1945 at the age of eighty. The Bullocks had four daughters— Mrs. Dora L. Bennett; Mrs. Minnie F. McGee; Mrs. Cora C. Plumlee, wife of Howard Plumlee and an aunt by marriage of Zelma Plumlee; and Mrs. W.H. Kirkland Sr., wife of W. Hubert Kirkland Sr.—and a son, W.T. Bullock.

"Thomas E. Standifer, retired Coppell farmer and cotton gin operator, died" in September 1948, according to a *Dallas Morning News* report. Standifer's wife, Maude, was the mother of Duncan Harrison.

Joseph Walter Thweatt, born in 1874, died in October 1946. "Thweatt, a farmer, was born in the Coppell community and lived there all of his life," the *News* reported.

"Things were changing, but we only knew what was going on right around us," said Zelma Plumlee. "Farm life was difficult, and you were

Coppell School burned down in 1949 and was rebuilt where Pinkerton Elementary sits today.

outside working most of the time. We were so busy on the farm. We spent ten to twelve hours a day working. So, news from the radio became more a part of our lives because of the war."

"We listened to the radio usually in the evenings," Burns said. "We listened to WBAP out of Fort Worth, because they gave the farmers the news about the markets for milk and cattle. My favorite program was *Amos and Andy*."

Late in the decade, another event affected the town. Coppell School was destroyed by fire in November 1949. The site of educational growth for area children, the venue for numerous county meetings advocating agricultural change during the Great Depression, the focal point for the community's scrap metal drives during the war and the official center for draft registration in town—the school had been a central part of the town's identity.

"The fire was discovered in the 21-year-old, 1-story building at 1 a.m.," the *Dallas Morning News* reported. "Before Grapevine firemen could reach the scene, the school house was destroyed...it is not known how the fire started. The building provided classrooms for about 155 students....it is going to be hard for the residents of that community to finance another school with building costs as high as they are."

Loss and sacrifice in the '40s changed rural Coppell.

DESTINY CALLS: THE 1950S

The Great Depression and the war were fresh memories. Coppell's destiny had been suppressed for two decades. A new era was dawning. The new decade had just begun when Coppell School Board president J.L. Ford announced that "a $36,000 school building will be raised in the Coppell District to replace the structure burned Thanksgiving night." Coppell voters had approved a $21,000 bond issue by unanimous vote of 35-0. "To the $21,000 bond issue will be added $15,000 in insurance money on the old building," Ford told the *Dallas Morning News*. "Six new classrooms and an auditorium were to be raised on the foundation of the old building."

Construction on the new school started in June for an eight-thousand-square-foot facility that would host 154 students. This new building is today part of Pinkerton Elementary on Southwestern Boulevard.

About the time construction began on Coppell School, the Korean peninsula erupted into civil war. Soon the war escalated into an ideological conflict of communism versus democracy. Americans were again engaged in a war.

Once more, Coppell men rose to the call of their country. In August 1950, Machinist's Mate Second Class John Butler of Coppell was serving aboard the attack cargo ship USS *Diphda* when he was notified that wife, Evelyn, had given birth to a baby girl, Beverly Virginia.

George T. Corbin, navy radar technician and son of Coppell's Andrew N. Corbin family, served aboard the Net Layer *Mulberry* in Korean waters. Just eight years earlier, during World War II, he had received a

citation for heroism for endangering his life while fighting a fire on an ammunition barge. Corbin was a navy reservist called back to active duty in November 1951.

In December 1952, William J. Etheridge of Coppell was a Seaman Third Class. He served aboard the aircraft carrier USS *Kearsarge* in Korean waters.

A month later, the *Dallas Morning News* reported that Master Sergeant Joe L. Bradshaw, son of Mrs. Nettie Lee Bradshaw of Coppell, was killed. His Strategic Air Command B-50 Superfortress aircraft crashed into a swampy rice field twelve miles west of Castle Air Force Base in California, as the pilot apparently attempted an emergency landing due to engine trouble.

In 1953, native son Bobby Ottinger, son of William "Mike" and Eula Ottinger, joined the army. He served in an antiaircraft division assigned at Thule, Greenland. After high school, Charles Miller and John Johnson joined the air force. Richard Lee joined a rocket battalion.

The early '50s also ushered in a North Texas drought that would last for seven years. Coppell residents remembered tough times.

"The drought went from about '50 to '57," said John Burns. "It didn't rain. We planted that whole bottom from Denton Tap Road to my place every year, and it didn't even come up. During that seven-year drought, I couldn't make enough money to pay my bank note on the cattle, buy my feed and live."

Servicemen returning from Korea came home to a new medium for communication: television. Unlike the '30s and '40s, black-and-white television sets quickly became the "box" around which Americans sat in the evenings.

"We got our first TV in the early '50s," said Zelma Plumlee. "One of our favorite shows was from Nashville—the *Grand Ol' Opry*. We watched it on Saturday night. We had first started listening to it on the radio."

"I think my brother had the first TV in Grapevine," said John Dobecka. "I remember the first show I watched was at his house, and it was wrestling."

In the early days of television, such sets were not cheap, and only a few could afford to own one. One Coppell-area family learned that early sets were prized items. Farmer R.J. Caldwell "reported Thursday that his house had been entered and his new TV set stolen," reported the *Dallas Morning News* in January 1951.

> He had reason to suspect the occupants of a car whose description he learned about from neighbors. Aroused by his loss, he did some patrolling around the area of his home in the Hackberry/Coppell area in Northwestern Dallas County. Caldwell has a brother who lives down the road and who also

recently set up a TV aerial. He reasoned that the same burglars might try to get his brother's TV set. Sure enough, Friday afternoon he saw a car fitting the same description drive up to his brother's house. He watched as the occupants got out and entered the house. He knew his brother was not home. Caldwell drove up to the house, too. The alarmed burglars jumped into their car and started off, but he flagged them down with a recently purchased automatic shotgun. And he held them there until help arrived, in the form of Deputy Sheriffs.

As more servicemen returned home from the Korean War, Coppell grew. In September 1952, the *Dallas Morning News* reported growth in every sector of the county: "At Carrollton, Mrs. Juanita Ross of the power company said an average of seventy-eight families is recorded every month for the Carrollton-Farmers Branch-Hebron-Coppell sector north and northwest of Dallas."

Land was being sought for development and population growth, but some Coppell farmers still grew a fair amount of cotton in the early '50s. In 1952, the *News* reported that a Coppell man brought in the county's first bale of the season and, thus, received a bonus.

"Dallas County's first bale of cotton from the 1952 crop sold for a $1.26 a pound Friday in an auction on the floor of the Dallas Cotton Exchange. Owner R.D. Harrington of Coppell received $711.90 for the bale, plus a premium of $1073.50 donated by various cotton merchants, insurance and steamship men and member banks. The bale, ginned by W.H. Kirkland of the Coppell Gin Company, weighed 565 pounds."

As growth continued unabated, the term "suburb" was born. "From cotton to commuters," reported the *News* in early 1956.

That's a three-word history of the years since World War II on the Dallas countryside....Small is the county space not under control of some municipal government....Typical is Farmers Branch....Today as one farmer remarked recently: "There isn't a farmer left within miles of Farmers Branch." Instead the farm lands of the old families form such vast building enterprises as Valwood Park with its 35,000 home sites, its huge shopping center area, and its sites for incoming industries....Cotton production, the original spur to Dallas' growth, slumped from a record 94,000 bales in 1914 to a paltry 10,000-or-less bales this season. King Cotton has abdicated to King Commuter—the man or woman who makes his living in an industrial plant, a bank, or a store—but who prefers to live in a suburb.

Coppell's destiny was now tied to growth in the area. In November 1955, an attorney from Denton named Shirley W. Peters assisted in an event that would formalize Coppell's future. "A petition signed by 34 residents of Coppell, northwest Dallas County community, has been filed asking County Judge Lew Sterrett to set an election for the community to incorporate," reported the *News*. The area the proposed incorporated city would cover would be a mile wide and 9,200 feet long, according to the petition.

By a 41-1 vote, the issue passed, and an alderman form of government began, with a mayor, five aldermen, a town secretary and a town marshal. Coppell's city limits were Coppell Road to Sandy Lake to Heartz to Belt Line and back to Coppell Road, two square miles.

The following was written about the new government: "The first meeting was held in the schoolhouse. The rest of the meetings were held wherever they could. After the second meeting, events of all types began here: Coppell started having to approve of garbage collection and fees, approve signs, talk to Texas Power & Light and the gas company, and [obtain] traffic ticket books." Lewisville State Bank was the city's first depository.

Within days, Coppell-area residents experienced a land rush. The *News* highlighted Coppell again:

Lewisville attorney Shirley Peters incorporated Coppell in 1955.

This tiny trade center in Dallas County's northwestern corner is 15 miles from Big D's outer limit, but land prices have spiraled to $600 and $1,000 an acre and big plans are in the wind. A big lake is being created south and east of town, a town government has been organized, and a deep well dug to provide the first community-wide source of water. For the town council, taxpayers elected R.M. "Pony" Johnson, retired salesman and Shetland pony farm owner, as first mayor, and five aldermen: E.E. Parker, employed by the Dallas public schools; G.T. Corbin, Chance Vought employee; G.C. Lanham, a plumber; V.E. Grace, a contractor, and C.C. Mitchell, a cattleman. W.A. Hodges, elected the first city marshal of Coppell, will serve without pay, and Roy Liberto, a Temco worker, will be Coppell's first city clerk, also without compensation.

The *News* article reported:

Postmaster G.O. Parker said the boom "has been fanned by the blocking of 1,700 acres of land on Coppell's south and east edges for a Dallas Power & Light Company lake." The power company still is buying land around Coppell in the basin of Grapevine branch, which will be a feeder stream for the new lake. Parker said land prices "range from $600 to $1,000 per acre" and that most of the buyers and land seekers are people from Dallas—"a good 15 miles away." Discussing the DP&L lake plans, Postmaster Parker said, "Grapevine branch is a pretty good-sized stream when it rains, but we haven't had any rain in a long time. The place they plan to dam is merely a big draw, but it will hold a lot of water." He said the biggest lake site tract bought by the power company is "the old Bullock farm of 600 acres." The lake planners also bought the lands from L.W. Yeargin, Charlie C. Moore, the Dr. Clifford Sanders farm, part of the G.R. Corbin farm, and acreage from Harry Byrd Kline, J. Bennett, and J.B. Pearson.

"Coppell's new water well," continued the *News* article, "was drilled 1,100 feet to the Paluxy sand and will be adequate to serve all of the 300-plus residents, plus a lot of newcomers. The Coppell townsmen decided to go ahead and drill the well and not to wait for long overdue rains to fill the power company's lake."

Later, in 1956, the *News* again noted the new city's development: "Early planning, such as that which Coppell leaders are doing, will bear good fruit in the years ahead…Coppell will hardly be recognized by those who knew it a decade ago. It not only has formed a city government, but it has adopted

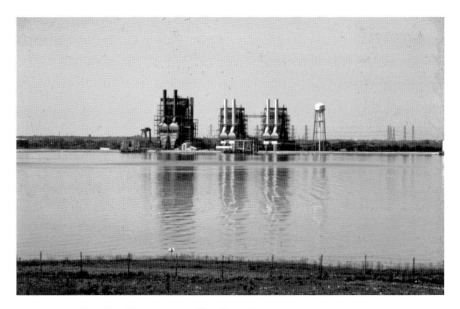

North Lake Power Plant, which served the area and was a towering landmark, was built on land belonging to Dallas.

planning and zoning to control its growth [and] it is looking forward also to dial telephones."

And, in June 1957, the new city of Coppell was estimated by the *News* to cover 1.75 square miles and host a population of 272. Real estate speculation caused by DP& L's new North Lake Power plant created a rush by property owners to be annexed into the new town. In 1958, the *News* reported the situation: "The new City of Coppell, expecting a boom with the coming of the Dallas Power & Light Company's multi-million dollar generating plant, has expanded its boundaries to embrace five square miles of Northwestern Dallas County. Mayor R.M. Johnson said the annexations, which enlarged Coppell's municipal area from two square miles, were made 'at the request of landowners in the annexed areas.'"

"We pushed Coppell's city limits to Elm Grove [Fork of Trinity] on the east, northward to Denton Creek, south to the Cotton Belt Railroad on the east side of Belt Line Road, and extended them a half mile south of the west side of Belt Line Road," Johnson said in the *News* article.

"At the same time, Postmaster Clyde Parker said, 'Our postal receipts are up 20 per cent over a year ago, and our office has been raised from 4th class to 3rd class. I have been postmaster since November 18, 1938, and operated the post office with my grocery store for eight years,' said Parker.

'But, we've had a rural carrier out of this office, Ira Coats, since 1922, and his business is growing too,'" the *News* reported. "Parker and Mayor Johnson said DP&L had 'big plans' for the new 900-acre lake in Coppell. 'It will be a fine recreation spot,' said the mayor. 'I understand they plan a municipal golf course there, too.'"

Coppell had its next election cycle in April 1958. Voters returned Mayor Johnson to office. Unopposed, he received the highest number of votes cast—forty-five. Five alderman positions were available, with seven candidates competing for election. Elected were C.C. Mitchell, C.T. Waters, Frank Harwell, John Burns and Ed Seger. Defeated were Ernest Gentry and Roy Storey. City Marshal Albert Hodges was also reelected with twenty-three votes.

A year later, 1959, the Coppell school district became an independent school district by a citizen vote of 98-6. Seven trustees were elected to serve the new Coppell Independent School District: S.P. Lesley, G.T. Corbin, one of the city's first aldermen, L.A. Jarrell, W.H. Kirkland, Bill Rush, Herbert Parker and Harold Arnesman,

The district was composed of an elementary school with approximately 250 students. Another 22 high school students were attending high school in Carrollton. Prior to the election, Coppell and Shady Grove were the last common school districts operating within the county.

A Fire Department Is Created

In May 1958, Mayor Johnson announced the town's first volunteer fire department, a twenty-man volunteer crew. It had been officially organized and blessed by Dallas County fire chief Hal Hood.

"Fire Chief Hal Hood did the Coppell area of northwestern Dallas County a fine service in organizing this department," the mayor told the *Dallas Morning News*. "This new department will have the responsibility for an area extending three miles in each direction," Johnson said. The department's first officers were Earl Tinsley, chief; Richard Lee, assistant chief; Don Plumlee, captain; and the Reverend Bruce Compton, chaplain.

"Hal Hood had been a sheriff's deputy under Sheriff Decker," said former Coppell fire chief Richard Lee, "and then he was appointed Dallas County Fire Marshall. He was putting together a mutual aid system in the county. There was still a lot of county territory at that time. So, he

Daily News Photo by Zenna Seastrunk

SOME WEEKS THEY RUN US TO DEATH!— Harvey James, volunteer fireman and supervisor at the Otis Engineering machine shop is pictured with his son Michael, 6, and one of three Coppell fire trucks. Michael assists his dad in fighting small grass fires. Fireman James enjoys the volunteer fire department "It's good public service; we have a great department."

Coppell began to establish city services, including a volunteer fire department.

contacted us, and somehow or another word got out. We got together and met with him at the grade school outside under the trees. He really thought we could get a volunteer department organized, and he would help us all he could. They did our bylaws and that kind of thing, gave us copies, just the standard form back then."

"I was one," said Bobby Ottinger. "Richard Lee, Bill Harwell, John Burns, King Tut, Earl Tinsley, Vernon Tinsley and several others were part of it—all volunteers. And, we took training. We trained once a week." Weldon and Don Plumlee were also involved.

"We had no equipment of any kind, of course," Lee added. "However, Arcadia Park was a little community on Davis Street, west of Dallas, and Dallas had just taken them in. They had an old '39 Chevrolet truck—an old gas truck that had been converted into a fire truck. They just gave it to us. That was our first piece of equipment. We parked it outside by the store between a hair salon and Miss Clayta Harwell's house, right there by the old water tower."

"Then, we found out that Carrollton was trying to sell a '41 Ford," Lee said. "This was about three, four or five months after we got the Arcadia Park truck. We bought it, and then we had two pieces of equipment. We joined the Dallas County mutual aid program. And, we agreed to protect what county area was around us. In doing that, we got $2,500 a year from the county. Back then, they also had money that was divided up by the number of fire runs made by everybody, which sometimes turned out to be pretty good sum of money, another couple thousand dollars."

"In '60 we bought our first new piece of equipment," Lee said. "It was a Ward truck…a Ford. It was a five-hundred-gallon-per-minute pumper. And, it was actually the third piece of equipment that we bought. It was brand new. Bill Cozby and the salesman went up to Elmira, New York, and drove it back. From that point on, we were pretty well equipped for what we had in town at that time."

"Shortly after we got that truck," Lee recalls, "we realized we had to have some kind of building. So, the city agreed to let us build a fire station there [in old downtown]. We built two bays. The firemen all helped. Travis Maynard was on the fire department at the time. We contracted with his dad, J.P. Maynard, to lay the block, the cinder block and the brick."

"The young city of Coppell didn't have taxes," Ottinger said. "There was no revenue for fire equipment. So, to raise money for the department, Coppell's volunteer firemen had fundraisings. We had a junior rodeo down there where Golden Triangle Trailer Park is now."

"The rodeo began in 1963 by S.P. 'Sammie' Lesley and Mickey Waters," said Vicki (Stewart) Marshall, who grew up living near the rodeo site. "When the rodeo first started, participants were called the 'Coppell Tigers.' It was bimonthly and continued for about seven years. The original site for the rodeo was on Coppell Road, right around the corner from Ruby Road where the Waters lived—now the Golden Triangle Mobile Home Park. Waters provided the site, and Lesley provided the livestock for the rodeo. It was open to kids nineteen years of age and younger and was held from May to September. I rode in the play days and ran barrels there also. Once the Waters sold their property, the rodeo was moved to the Wagon Wheel Ranch on Coppell's west side."

"So, we had our chili suppers and that kind of thing to raise money," Lee said. "Then, we started buying coats, helmets and boots. And, we bought a resuscitator that the guys still have. For a while," Lee recalled, "we left the little Ford down on Sandy Lake Road, across from what used to be Tut's

Store. So they had a piece of equipment down there, and then we had one up here [downtown]. Of course, Tut was on the fire department and some of the guys down there, too. We finally put 'em all back here together at the central fire station."

"In 1967, I became fire chief," Lee said. "We were an all-volunteer fire department from '58 to '70, up until I hired Randy Corbin in '72. He was the first paid fireman. He worked eight-hour days, Monday through Friday. I remember one problem we had was that all of us worked someplace else. So, having him here helped, and there was always Joe Cozby, Tony Dobecka and Johnny Dobecka; they were volunteers close by. We'd have five or six volunteers usually around here during the day."

"Our biggest problem I guess was grassfires back then," Lee reminisced. "I remember the first house fire we had was down on Allen Road at Wheeler Dairy. It was in a kitchen. It was right after we organized. We didn't have anything but that Chevrolet truck that they'd converted from a gasoline truck. We got there quick enough and there was quite a bit of fire in the kitchen. So, we thought we were firefighters. Of course, it didn't take long to realize that we weren't that good. We had a lot to learn."

"We all went through advanced first aid in the fire department," Lee said. "We did that early on. Then later I decided we had to have something better than that. So, we started talking to the county about Emergency Medical Technician (EMT) training, and some of the people that were thinking about getting into it. We decided we'd do that and started to train EMTs. We couldn't train at Parkland 'cause Dallas had it pretty well tied up with so many people they were trying to train. So, the assistant county fire marshal and I started calling different hospitals in the area to see if they would hold EMT courses. We talked to Baylor in Dallas, and they had a young emergency room doctor

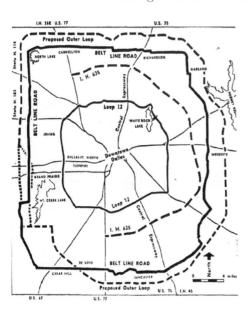

Belt Line Road, a major thoroughfare that extends both east and south in Coppell, was built to link metroplex cities and highways.

130

who wanted to help. So, that was the first EMT school outside of Parkland in the county. And, we set that up."

"Then, in '73, we got our first ambulance," Lee said. "It had a high top back. We ran that for quite a while. And, then, we got a modular ambulance in '81. That was the first ambulance like they've got now, only it wasn't quite as big. We still had EMTs. Then in '83 we got the new American LeFrance fire truck. We were getting some pretty good-sized structures by then and needed it. I retired in January 1985 and had been with the fire department since March of '58."

By 1960, the *Dallas Morning News* described Coppell, population six hundred, as the "last frontier" because of all the undeveloped land. Since incorporating only five years before, only twenty-five new homes had been added to the city. "But the frontier is about to fall," said the *News*, referring to many real estate people who had begun to inquire about developing land in the city.

As the decade of the '50s came to an end, Cold War tension between America and the Soviet Union was at a peak. Civil Defense became an emergency preparedness program in every city, and Coppell was no exception, becoming part of Dallas County Civil Defense Division II and incorporating survival techniques into community awareness. Seminars and information on preparedness, first-aid skills and radiological fallout were common. Coppell schoolchildren were taught to take shelter under their desks when Civil Defense sirens sounded.

World events, city life, public welfare and the responsibilities that went with them had arrived.

The Turbulent 1960s

When Denton attorney Shirley Peters incorporated Coppell in 1955, he was not aware that his legal expertise would create the town, and then, in the mid-1960s, be asked to tear it apart. The perceived lack of fire protection, anger over taxes, lack of city services, vindictive personal attacks, mean-spirited political shenanigans, insensitive attitudes and years of "good old boy" politics that divided those citizens "up town" from those among the Sandy Lake Road nightclubs and farms came to a head. The seeds of bitterness had been festering for years. Within Coppell, a political war was bubbling beneath the surface. It would get ugly—and Shirley Peters would be right in the middle of it.

This turn of events had been forecast just months after Coppell was originally chartered. On New Year's Day 1956, the *Carrollton Chronicle*, a weekly newspaper published by Nick Sindik, actually predicted that within two years Coppell would merge with Carrollton, Farmers Branch and Addison to form one city. Sindik, a former chamber of commerce president, wrote in a New Year's Day front-page editorial: "Predictions for 1956–57 indicate that the communities of Carrollton, Farmers Branch, Addison and Coppell will enjoy a better understanding of mutual problems and thereby will solidify behind a united effort for closer ties between the cities. A strong effort, therefore, will be weighed to merge the entire area into one large city to the mutual benefit of all." He cited two reasons that would precipitate the merger: "One, unforeseen heavy demands for water, sewer, and sewer disposal facilities have become too great for individual municipalities; and

two, zoning problems have developed as communities have overlapped in their tremendous growths."

Note that Sindik's prophesy was for 1956. However wrong he was about the date, his forecast of utility demand was prophetic for Coppell-area residents. In the 1960s, this demand for utilities by some Coppell residents led to a litigious decade that almost destroyed the community.

Divisive attitudes began just after the 1958 annexation of additional land along Sandy Lake Road to the east, Highway 121 to the west and the Cotton Belt Railway to the south. Coppell comprised about five square miles. It's important to remember that since Coppell could not annex land by itself, these property owners had to petition Coppell to come into the city. Yet, the "Miracle Mile," the area originally chartered as a mile wide and 9,200 feet long, was considered by many as "uptown." Thus, the focus of the fledgling town remained on that area, and the new Sandy Lake Road citizens were simply viewed as farmers situated among honkytonk clubs.

The '60s opened with a city election. In April, William Trimble Cozby was installed to succeed R.M. Johnson as Coppell's second mayor.

"You had to pay a poll tax in order to be able to vote," said Bobby Ottinger. "You had to pay each year. You got a vote card like we've got now, but you had to pay for it. I don't remember how much it was. It was very little. Yet, a lot of people wouldn't do it, because they didn't believe in paying taxes."

"They [the uptown folks] had all the votes," Sandy Lake Road resident John Burns said. "They had all the churches and they had all the votes; we had all the land. But, they could outvote us."

Initially, the city didn't have any taxes. However, the school district did have a tax on all landowners within the Coppell Independent School District. In those days, the school board hired a local citizen to oversee tax equalization among landowners within the district in lieu of the centralized county assessment procedure used today. This individual placed a tax valuation on property as he saw fit. As such, the property value could sometimes be subjective, not objective, in assessment and could be somewhat happenstance in what was assessed. Such was the situation brought before Coppell's board of trustees early in the decade. Fairness of the tax was called into question.

A landowner "had water on the west side of Denton Tap Road," Burns said. "And, where he had the water he had cattle. But, the city wouldn't let him have water on the other side of the road. Yet, the school district was taxing him for both sides."

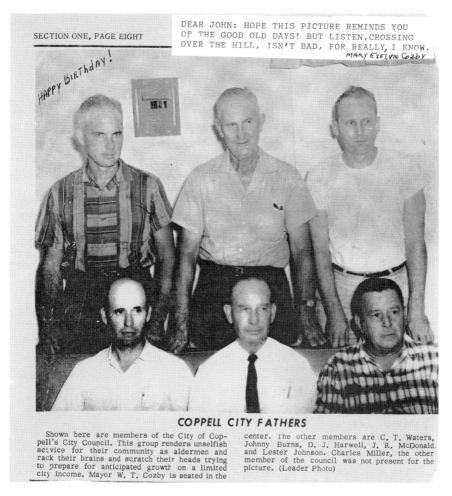

SECTION ONE, PAGE EIGHT

DEAR JOHN: HOPE THIS PICTURE REMINDS YOU OF THE GOOD OLD DAYS! BUT LISTEN, CROSSING OVER THE HILL, ISN'T BAD, FOR REALLY, I KNOW.
MARY EVELYN COZBY

HAPPY BIRTHDAY!

COPPELL CITY FATHERS

Shown here are members of the City of Coppell's City Council. This group renders unselfish service for their community as aldermen and rack their brains and scratch their heads trying to prepare for anticipated growth on a limited city income. Mayor W. T. Cozby is seated in the center. The other members are C. T. Waters, Johnny Burns, D. J. Harwell, J. R. McDonald, and Lester Johnson. Charles Miller, the other member of the council was not present for the picture. (Leader Photo)

An early Coppell City Council, with W.T. Cozby as mayor.

By late 1964, the city followed the school district's lead and levied its first twenty-five-cent tax over its five-square-mile area. Again, citizens along Sandy Lake Road thought that only the "Miracle Mile" was getting the benefit of the money. Citizen tempers often flared in public meetings, and sometimes individual councilmen experienced citizen wrath as well.

"The city council voted in a twenty-five-cent tax." said Burns. "And, somebody was so upset that they beat the whole front end off of a car that belonged to one of the council members just for voting in favor of the tax."

"Things like that happened all the time," said Ottinger, also a resident of Sandy Lake Road. "It's part of growing up as a city."

Taxes and the indiscriminate manner in which those taxes were levied, collected and used festered. Sandy Lake Road residents began to demand services for the taxes they paid. "Water and sewer was the big thing," said Ottinger.

"They wouldn't give us any services," Burns said. "So, I went to see Shirley Peters. He practiced law in Denton. He had an office right across from the Denton courthouse. There was a big sign on his desk that you saw when you walked in, a big sign, and it said, 'Sue the bastards.' So, that's what we did."

The cast of characters was set; the issues were defined. Citizen protests of Coppell's 1964 tax levy as "illegal and discriminatory" increased. Expectations of city utilities by Sandy Lake Road residents became futile. Hard feelings grew. Compassion and reason became blocked by bitterness and anger. A political storm between "downtown" and Sandy Lake Road residents was brewing. Desperate means were afoot.

CITIZEN LAWSUITS DIVIDE CITY

In the midst of this escalating feud, a young graduate of Baylor Law School passed the bar exam and moved to Dallas to find a job. "I got out of law school and was looking for a place to start practicing law," said Larry Jackson. "And, I drove to Dallas, looked at the tall buildings and started looking in the Republic Bank building. I went up to the top floor and started hitting every law office there was, and when I got down to the twelfth floor I had a job."

"The firm of Saner, Jack, Salinger, and Nichols represented a number of municipalities during that period of time," said Jackson, "and my job was to go out and serve as their city attorney. Coppell was one of 'em that I went out to and I just started doing everything for Coppell."

The young lawyer didn't have much time to settle into his job as consulting city attorney before politics heated up in Coppell. In May 1964, Sandy Lake Road resident John Burns and three other citizens of Coppell filed suit in district court seeking an order directing Mayor W.T. Cozby to call an election to disannex a major portion of the town. The suit was dismissed, because such disannexation would have left the town with less than the square mile of area required by law. However, undaunted in their commitment, Burns and petitioners revised their request to disannex and filed again six months later.

The *Dallas Morning News* reported the ongoing tax revolt in Coppell: "A long standing controversy over the town government of Coppell in Northwestern Dallas County erupted anew Friday when County Judge Lew Sterrett was presented a petition seeking an election to dissolve the town." The petition contained 101 citizen signatures. Only 25 were required by law. After validating the signatures, Judge Sterrett ordered the election to be held.

"The 1,215 residents of the 12 square-mile town have been split over several issues since it was incorporated in 1955," the article continued. "The most recent issues have involved both city and school taxes which some of the residents feel have been grossly unequal. John H. Burns, one of the petitioners, said the present City government has assessed taxes on all residents of the community in order to pay for water and sewer construction in a square-mile area which encompasses the downtown section. He charged that City officials had assessed higher valuations on property in the [remaining] 11-square-mile area which will not benefit from the construction than was assessed property in the downtown area."

"We don't think this is fair to the rest of the town," Burns said. "But the board of equalization won't do anything about adjusting the tax."

Burns's comments and convictions had credibility with a number of area residents because he had served on the Coppell City Council from March 1958 through March 1964, a time frame when there was no city tax at all. Shortly after his departure from the council, a twenty-five-cent city tax was passed.

"We feel that they [city officials] just want to hold us in the town for tax purposes," Burns told the *News*.

Note that Burns and the Sandy Lake Road residents had petitioned Coppell to annex them *into* the city just six years prior, as Carrollton and Irving were attempting to take them into those cities. Now, they were asking a Dallas District Court to force Coppell to hold an election to dissolve some of those same areas of Coppell. The issues were about a lack of city services and unequal taxes.

"He [Burns] said that the dissident residents had not talked with officials of adjacent cities concerning the possibility of the area becoming a part of them should the town be dissolved," the *Morning News* article reported.

"We would rather not be annexed by anyone," he said. "We just want to abolish what we have and start over from the beginning to form a new town with a new government."

"Another issue that has split the town's residents," the *Morning News* article stated, "is school taxes which complaining taxpayers say are unequal." In 1961, Coppell residents had approved a $120,000 bond issue to build a junior high school. The vote was seventy-one for and twenty against. School superintendent G.T. Phillips had stated the addition of the new junior high school would increase the district's total enrollment from 234 students to 300. By 1964, the junior high had become a District II-B high school without a twelfth grade. In lieu of sending students to Grapevine High School, Coppell Independent School District was expanding its own facilities. Within two years, a district bond issue for $400,000 was envisioned for expansion into a full high school. School taxes and appraisals were again an issue.

So, an additional lawsuit against Coppell Independent School District was filed by Sandy Lake Road residents. It, too, alleged discriminatory and unequal practices for tax assessment. The suit asserted that school districts were required by the state constitution to use property valuations set by the county tax assessor-collector. The petitioners argued that the school district did not have the right to hire its own tax assessor-collector and set up its own tax equalization board. They maintained that when school trustees hired a local citizen to oversee tax equalization, such valuations could not be objective and were happenstance, thereby, supporting a form of "good old boy" politics.

The political challenges, which had already become bitter and mean-spirited, became litigious and public. Sandy Lake Road residents went head-to-head with downtown. The election to dissolve Coppell was set for November 21.

By November 20, "Save Coppell—Vote Against Abolishment" signs were all over downtown. And Mayor Bill Cozby was firing back at the Sandy Lake Road dissidents. He mailed a letter to the town's residents. Again, the *Dallas Morning News* carried the story, quoting the mayor's letter: "This is the same group that has been fighting the Coppell School District and every other community proposal. If the Town of Coppell is abolished the Cities of Dallas, Irving, Carrollton and Grapevine would at once acquire jurisdiction over the Coppell area; this is because the Municipal Annexation Act of Texas gives each city control over and the right to annex land which lies within a certain distance from its boundary line. It is most important to remember that under Texas law no new city or town could be formed in the Coppell area unless all of these cities agreed to give up their jurisdictional control."

Addressing the demand for water and sewer, Cozby wrote that, if dissolved, the land would be annexed by another city: "It is not true that

these four cities would have to supply governmental services to the area." Regarding taxes, he stated: "Coppell's taxes are assessed at a much lower rate than in the four cities of Irving, Grapevine, Carrollton and Dallas." He compared Coppell's tax levy of $6.25 per $5,000.00 gross valuation to tax levies in the four neighboring cities ranging from $26.25 to $36.00 per $5,000.00 valuation.

Election Day arrived. Citizens registered their collective will at the polls. Cozby prevailed. Coppell residents voted 193 to 117 to retain their twelve-square-mile town.

The day after the city victory, the Coppell Independent School District also won its suit. The Fourteenth District Court granted Coppell school trustees a judgment after studying the state constitution and state laws. This left trustees free to collect taxes on valuations set by the assessor-collector they employed.

Coppell city government and the school district had both dodged separate and serious legal challenges, but the issues went unresolved. The Sandy Lake Road petitioners were determined to get tax equalization and services.

Dallas attorney Eric Eades Jr. had represented the petitioners within the Dallas County judicial system. However, behind the scenes, Denton attorney Shirley Peters, now retired, still guided residents of Sandy Lake Road through the numerous legal options available to them in their fight against city hall.

Thus, the city's involvement in litigation was just beginning. "They started bringing lawsuits against the city and school board," remembered city attorney Larry Jackson. "And during that period of time, they brought anywhere from twenty to twenty-seven different lawsuits against the city."

DISANNEXATION EFFORT BEGINS

In late 1964, the Miracle Mile (downtown Coppell) had obtained water and sewer. Sandy Lake Road residents alleged taxes were being collected citywide to support enhancements for "downtown" services. Sandy Lake Road residents were determined in their demand for city services. Yet Coppell repeatedly refused to provide such services. The sides were at an impasse. A city election was coming, and something had to give.

"I received word that Coppell was going to disannex everything north of Sandy Lake Road from Heartz," said Burns. "Everything to the river was about fifty-four votes."

Prior to the election on March 1, 1965, the city council passed an ordinance that cut apart from the city an area north of Sandy Lake Road. Coppell City Council minutes of that meeting confirm Burns's story:

> *Mr. Cozby stated that since the council had discussed the disannexation of certain parts of Coppell at a previous meeting that the time had come for the council to take action on this because he felt that it was in the interest of the majority of the people. Mr. Cozby stated that for two years the council had tried everything possible to work with this certain area and that they had not been able to get their cooperation. He stated that he felt that it was time the council took action on the matter. C.T. Waters made a motion that the council adopt Ordinance No. 20., W.H. Wilson seconded the motion and the motion carried by the following vote: Ayes: Waters, Dobecka, Wilson. Noes: McDonald, Harwell.*

As a direct result of such action, a water and sewer bond election on March 27 and a city council election on April 7 were held without votes from the disannexed areas. The water and sewer bond, which did not provide services to many Sandy Lake Road residents, passed. The election returned Mayor Cozby to office, and voters endorsed his slate of five councilmen.

Based on successful passage of the water bond election, Coppell applied for and received in March 1966 a loan for construction of a water and sewer system for the "Miracle Mile." The loan was received from the Department of Housing and Urban Development for $440,000. Construction of the water and sewer lines was projected to be completed in mid-1967. Not included in the projected sewer and water improvements were residents along Sandy Lake Road.

"They put us out and wouldn't let us vote," Burns said. "Cozby was reelected by twenty-seven votes. We had about fifty-four voters that were denied the right to vote. If we were not disannexed prior to the election, we would have won by more than twenty votes. And that's why they put us out, so we couldn't vote in the election."

Still, efforts by additional citizens continued in earnest to disannex from Coppell, form their own town and provide a water and sewer utility district. "The Coppell City Council has received another petition—this one with 55 signatures—asking the disannexation of all but two or three square miles of

this 10-square-mile municipality in Northwest Dallas County," reported the *Dallas Morning News*. "'This is the third disannexation petition the council has received in the last two years, and the signers are mostly the same people who signed the others,' said Mayor W.T. 'Bill' Cozby. 'They want practically the same area disannexed, the north and east parts of Coppell, leaving two or three square miles of our town in the southwest. Their first petition was withdrawn, and the second petition for disannexation was ruled void by the court because of a 10-foot strip around the area proposed for disannexation. It is my opinion that if we have to call an election on the petition, the disannexation will be turned down.'"

In April 1966, sixty-four residents petitioned Dallas County judge W.L. Sterrett to call an incorporation election for "Jamestown." "We are still trying to incorporate a four-square-mile area east of the Elm Fork of the Trinity," Sandy Lake resident Jesse Ford told the *Morning News*. A disannexation election, the second within two years, was set for the first Saturday in December 1966.

Coppell's hardball politics played to win. Jamestown's lawyers and its proposed utility district were portrayed as promoters and outsiders. Again citizens were urged to save their town. The *Morning News* reported the heated controversy: "A citizens' group Wednesday charged that promoters are trying to take over Coppell's public utilities and residents were urged to vote Saturday against the proposed disannexation of 'four fifths of Coppell.'"

"These outsiders will operate the water and sewer services [if disannexation is voted]and would not be accountable to the voters as the city council is," alleged the Committee Against Disannexation, a group of Coppell citizens made up of C.T. "Mickey" Waters, James McGibbony, Charles Brown, Billy Self, Sam Leslie, J.R. Sowell and H.H. Parker.

"If disannexation is voted, the portion of Coppell that is allowed to remain would be stripped of its sources of revenue for water and sewer services, but [remaining] taxpayers would still be obligated to pay off water district bonds," the committee charged. "The town of Coppell is in jeopardy. These outsiders have brought 14 lawsuits against the town council in the last 30 months, and in every case, the courts have ruled the lawsuits unjustified, but the promoters have succeeded in shaking the confidence of some voters."

Mayor Bill Cozby said the disannexation proposal involved about seven square miles of the existing town. The town covered about nine square miles in northwest Dallas County. "In the history of Coppell, there will never be a better time to vote against disannexation and for the preservation of our town," said Cozby.

Disannexation was defeated for the second time. The vote was 209 against and 100 for. Mayor Bill Cozby called the election "a victory for the city. The majority of the people are very happy." He said he hoped this vote would be the end of disannexation efforts. Ironically, contrary to his own statement, it was Cozby, not a citizen petition or popular referendum, that affected the disannexation of a large portion of north Coppell. This action would soon come back to haunt Cozby, his young city attorney and Coppell.

JAMESTOWN PROPOSED

It was Joe Driscoll who came up with the name Jamestown. He was a San Antonio oilman who was trying to create a water and sewer district in the area. He had secured, through options, a thousand acres of land along Sandy Lake. "Driscoll named it," said John Burns. "He didn't say why. He just said 'We'll call it Jamestown.' We were going to form a town and take it clear up almost to downtown Lewisville. And, that's why we were trying to get loose from Coppell."

However, Carrollton, sensing weakness after two election defeats in Coppell, did not wait long for Jamestown to come together. By mid-January 1967, just three months after Ford's statement about receiving incorporation approval from Carrollton, Carrollton began a land grab. "Carrollton wanted to jump the river because they couldn't go north," said Burns. "Hebron had them boxed in there. We were going to get Vista Ridge, but Carrollton wanted the same thing."

A square mile of the proposed Jamestown site was annexed by Carrollton. "This will leave a square mile of the townsite in the county and outside both towns," said Coppell mayor Bill Cozby. "We don't know what these fellows will do next. They may now file against both Coppell and Carrollton."

Sure enough, Sandy Lake residents responded with litigation just two weeks later. "The proposed township of Jamestown was saved from annexation Tuesday when a district judge granted a restraining order against the City of Carrollton," reported the *Dallas Morning News*.

John Burns and Mrs. Willie B. Cook filed the latest petition on behalf of 64 persons in the area. They alleged that while they were involved in court disputes concerning disannexation from Coppell, Carrollton officials moved to incorporate their area. They asked that District Judge Dee Brown

Walker of 162nd District Court restrain Carrollton from any action pending the outcome of their attempt to incorporate Jamestown. The 64 residents had previously asked County Judge W.L. Sterrett to call an incorporation election for Jamestown. Later, the suit alleged Carrollton and Dallas gave the attempt their required approval. The suit stated that the petitioners had until November 31, 1967, to incorporate.

Sixty days later, Carrollton was at it again. Jamestown land appeared to be fair game. Again, the *News* reported Carrollton's land acquisition: "We took about one half of the area formerly proposed as the site for the new town of Jamestown," said Mayor Robert J. McInnish in noting his city's latest annexation move. "We extended our city limits about one mile west of our present limit west of the Trinity River, then northward into Denton county about a mile. Our west boundary will be 1,000 feet east of DeForest Road" The article reported: "Mayor McInnish said Carrollton gained about 250 residents in the annexation and that his city's population was now estimated at 14,500."

The situation looked grim for Jamestown. Coppell would not disannex the anticipated seven square miles of land. Carrollton was taking more and more land to the east of the proposed townsite. Thus, the proposed and long-anticipated Jamestown townsite was now left with about one square mile, and Carrollton officials had eyes on that land, too. Since Coppell had disannexed them, Burns, McDonald and other Sandy Lake Road residents were now facing a significant threat of being annexed into Carrollton. And taxes in Carrollton were higher than Coppell.

"I got a call from the attorney that was representing some of the people north of Sandy Lake Road," said Coppell city attorney Larry Jackson. "He said, 'It looks like Carrollton is going to take over everything north of Sandy Lake Road.' We didn't think that would happen. How can we get back into Coppell? And, I said they would have to prove that Coppell disannexed them improperly. So, it would take a lawsuit to get 'em back into Coppell."

Suit to Rejoin Coppell

Thus, by late 1967 an ironic situation had developed that stunned Coppell, its citizens and the Dallas County judicial system. Those same citizens who had petitioned so strongly to disannex from Coppell, those same citizens

who had fought almost every city and school tax increase, those same citizens who had filed some twenty lawsuits against the city, those same citizens who aspired to be part of a new "Jamestown" community—now wanted to come *back* into Coppell.

The *Dallas Morning News* reported this turn of events: "Residents of an area disannexed by Coppell went to court Monday in an effort to be re-annexed by the town. Witnesses said they first wanted to form Jamestown, a new municipality, but Coppell declined necessary permission. Higher-taxing Carrollton has made advances toward the disannexed area, so residents hope to get back behind the skirts of Coppell. This suit is the 20th concerning feuds over Coppell and Jamestown within recent years, a witness said."

"So, there was a lawsuit," said Jackson, "that was brought by the citizens who were out of the city to get back in. The lawsuit alleged the ordinance that disannexed them was invalid. There was a provision in the law at the time that you couldn't have a certain number of people living within an area that was disannexed. What the court held was that one acre could make up a long strip. And, so, there were more than three houses in a long strip along Sandy Lake Road. It turned out that the way it was disannexed was held by the court to be invalid."

On November 15, 1967, the *News* reported the verdict: "Ordinances which disannexed the Jamestown area of Coppell were ruled void Tuesday by a district court jury. The jury ruled that the area was not as sparsely populated as the Coppell city fathers claimed in the disannexation ordinances. They also found that the majority of the Coppell City Council conspired to disannex the area to keep residents from voting in two elections."

"They got convicted of conspiracy, denying my right to vote," said John Burns. Burns, who had previously served Coppell as a councilman, constable, volunteer fireman and on the school district's tax board of equalization, said he had asked Dallas County district attorney Henry Wade to file a suit against Coppell challenging the disannexation.

"It took losing a lawsuit to get 'em back into Coppell," said Jackson. "I battled it hard. I felt an obligation to Coppell to fight the case and I put up a strong argument. During that period of time, they brought anywhere from twenty to twenty-seven different lawsuits. The only one we lost was this one. The rest of 'em we were successful in defending. However, this was one lawsuit that I really didn't mind losing. Otherwise, Carrollton was going to annex that portion of former Coppell."

In his late teens at the time, Pete Wilson, son of former Coppell councilman Wheelice Wilson and now a member of the Coppell Historical Society, recalled "the political warfare that raged when we were struggling to establish Coppell as a city and as an independent school district."

"How fortunate we were that Larry Jackson, a young lawyer, came to serve as Coppell's first city attorney," said Wilson. "My father respected him throughout his life. Larry was always there, meeting with the council, 'til midnight sometimes. If it had not been for his legal expertise, we would not be where we are today. Two other lawyers may have spearheaded incorporation and dealing with the power plant, but it was Larry Jackson who guided us through the maze of impediments of the sixties."

City attorney Larry Jackson led Coppell through the legalities of the turbulent '60s.

Five months after the jury's verdict, Coppell received an award of $106,000 from the Department of Housing and Urban Development for expansion of its water and sewer systems. The money was an advance on a $500,000 bond issue passed in 1965. According to the *Morning News* article, "Mayor Bill Cozby said the money would be used for construction of the municipally zoned sewage system and for expansion of water lines to include homes on Heartz, Sandy Lake, and Denton Tap Roads."

"We have to remember that, in those days, the Sandy Lake Road area, northeast of the main part of Coppell, was a depressed area," said Pete Wilson. "For a century after settlement began in this area, Sandy Lake Road was occupied by persons who had to endure the cruelest natural conditions. All of that area was all in the floodplain. When the Trinity River would overflow its boundaries, houses would be totally submerged. Substandard roads, like all the others in early Coppell, got even worse when they turned to mud."

"It was much more obvious in those days that the Sandy Lake Road area had more serious problems to solve before water and sewer lines could serve anyone in that area," said Wilson. "Working farms, like those of some of our opponents, were so sparse and so separated from other farms, it was unrealistic to suggest that, early on, they could be reached by a primitive

water and sewer system."

"Mayor Cozby said that it looked like the opposition was going to be able to wear us down, that by filing lawsuits and delaying every move we made, it was costing too much in time and money for the city. Despite the fact that we consistently won elections and outvoted the others, they were so tenacious and so mysteriously funded, we were dangerously close to losing our vision for the city. He said that the council had decided that those who wanted to be cut off from Coppell should be allowed to go. Once the action was taken, Coppell could devote its efforts to the plans that were already underway, and the others could make a new 'Jamestown' or whatever they wanted. Both sides would be better off," said Wilson.

"Despite my completely biased opinion at the time, I now realize that the court did us a great service in keeping Sandy Lake Road inside our city limits," said Wilson. "Fortunately, the dust settled and the world did not come to an end and the Sandy Lake Road opponents grew less powerful and less vocal. We started moving ahead with zoning, expanding city services, and with plans for an independent school district. What Coppell is today, good or bad, was established in the early 1960s by people who were willing to put in endless hours for what they considered was obviously good for our residents."

Thus, Coppell was geographically whole again. Politics of the day were still serious and many times personal. However, there was some lighthearted kidding among those who knew John Burns as the catalyst behind most of the legal challenges the city had faced. "John was real good to us," said forty-two-year resident and retired Assembly of God church pastor C.A. McBride. "John was good to everybody that would let him. He was riding in the car with me one time. I said, 'Now John, you know how things are here in town. And me being from the Miracle Mile, I'd really appreciate it if you would just bow your head real low so nobody could see you when we drive through town.'"

"Many years have gone by," said Wilson, "and we have all mellowed; things have settled down since those controversial years, thank goodness."

A City Evolves: The 1970s

Disannexation was finally settled, but citizens' request for water and sewer continued. This quest was a significant part of Coppell's history. Once resolved, the decision moved the community toward prosperity and growth.

Water and Sewer Services Expand

Several important events set the stage for this part of history. In 1964, San Antonio oilman Joe Driscoll had come to Coppell and offered to build a water and sewer district for residents along Sandy Lake Road. He successfully optioned land for a one-thousand-acre water and sewer system, but the Coppell City Council voted the proposal down. The council did not like the idea of having outside interests running the city's utilities.

However, in 1965, Coppell began to plan a sewer system for the downtown area. A water bond issue in the amount of $500,000 was passed. Coppell applied for and received in 1966 a loan for construction of a water and sewer system for the "Miracle Mile." Construction of the water and sewer lines was projected to be completed in mid-1967. Not included in the projected sewer and water improvements were residents along Sandy Lake Road.

Then, in 1967, the city filed for permission to build a municipal sewage treatment plant on a tract of land about seventy yards north of the Cotton

Belt Railroad line at the Elm Fork of the Trinity River. Permission was needed from the Texas Water Pollution Control Board to discharge municipal wastes into the river. This permit was critical if Coppell's sewer system was to be put into service.

In 1968, Coppell received an additional $106,000 from HUD for expansion of its water and sewer infrastructure. This money was an advance on the $500,000 that Coppell voters had approved in 1965, when several Sandy Lake Road residents had been disannexed. Mayor Bill Cozby told the *Dallas Morning News* "the money would be used for construction of the municipally zoned sewage system and for expansion of water lines to include homes on Heartz, Sandy Lake and Denton Tap Roads."

Coppell's water at that time came from wells. Its newest well had been drilled the previous year, also with a $60,000 advance from HUD.

However, Coppell's entry into the sewer-treatment business was short-lived. By 1970, the Trinity River Authority's Central Sewage System plant had expanded to include the Elm Fork of the Trinity. This new addition to the TRA plant stopped the discharge of partially treated sewage from four Dallas County cities into the Trinity's Elm Fork, through which Dallas obtained its freshwater supply. The new TRA sewer line began collecting sewage from Coppell, Carrollton, Farmers Branch and Addison for processing at the Central Treatment Plant. TRA's extension into Northwest Dallas County was also timely, as development of the new regional D/FW Airport was requiring hundreds of miles of water and sewer lines. And, by late 1971, North Texas cities had approved a regional sewage plan that would centralize treatment and phase out forty-seven small sewage plants in Dallas and Tarrant Counties. Thus, Coppell's entry into sewage treatment and discharge into the Elm Fork lasted less than two years.

By the late '60s, the "Miracle Mile" had water and sewer service. However, sewer service only served downtown, and even then it had problems. Hulen Scott had lived in Coppell only one year when, in 1971, he ran against incumbent Bill Cozby, who had served eleven years as mayor.

"Sewer was a big issue," Scott said. "As far as the people on Sandy Lake Road were concerned, the regional sewer [of the late '60s] wasn't put in properly. It only served the Miracle Mile, the downtown area. The downtown group was being called 'The people in the sewer.'"

"For others," Scott added, "sewer was also an issue in that the regional sewer wasn't installed right. In the Parker Addition, everybody knew how many problems we were having then. The sewer line was either level or going the wrong way. It didn't flow right. If it was put in right, we wouldn't

have had to have a lift station. Evidently, Coppell was ready for a change of some kind."

Official records indicate that Coppell was ready for change. In the election of 1971, all incumbents were defeated. "I think they had about 140 or 150 block votes," Scott said. "And, to beat those I had to get more than that." Cozby only received 40 percent of the vote. Scott garnered 60 percent of the vote. Two of Cozby's incumbent councilmen were also defeated. The vote tally depicted a voting block pattern—downtown sewer verses non-downtown, no sewer. The number of votes received by each of the three defeated incumbents, including the mayor, was within one vote of one another. Each of the winners was within ten votes of one another. The quest for water and sewer had become *the* political issue in town.

"One of the first things we did was to get a master plan going for serving the needs of the whole city," Scott said. "Of course, the one thing that made that master plan deal go over so well was the fact that I appointed [former mayor] Bill Cozby to head it up, you know, to get the deal working with citizens. And that made the downtown folks happy. That helped bring the city together, too."

HUD grants were applied for in an effort to fund sewer and water improvements. However, this was a slow process.

In December 1971, Councilman Ted Ruppel resigned and moved out of town. That left a vacancy on the council. Sandy Lake resident John R. Burns, the son of '60s activist John H. Burns, was appointed to take his place. "Johnny Burns was appointed," Scott said, "for three or four months until election time, from January to April 1972. And that's the thing that stirred the downtown folks up. Before Ruppel resigned, the voting block was representing the people downtown. Ruppel was a downtown guy. When he resigned and Johnny got appointed, that represented a majority power shift on the council. The voting block that was 3-2 for downtown moved the other way 3-2 for Sandy Lake Road. That's the politics of all that. The power shift went toward Sandy Lake Road when Johnny Burns was appointed. So, when Wheelice Wilson and Billy Harwell didn't think they could get reelected in the upcoming council race, they got three new guys to run: Don Carter, Sam Tiner and Bob Hefner. And, they ran to bring that power block back to downtown."

"I don't like to remember bad things," Hefner said years later, "but the truth is the town was divided. There was kind of the downtown and then there was the Sandy Lake people, a lot of division in the town. And, the big thing was over water. When Don and Sam and I talked about running, we

formed a ticket. And, as we were talking to people, we'd tell them 'If you don't vote for all three of us, don't vote for any of us, 'cause one person can't do anything. We've got to have three votes.' And, our slogan was 'Unity, try it, you'll like it.' And, we put that on posters, wooden nickels, balloons for the kids, everything. We all three went in together with our aggressive agenda."

The city council election of 1972 saw a reversal of political influence in Coppell, as three incumbent councilmen, Wheelice Wilson, Billy Harwell and John R. Burns, did not seek reelection. Nine candidates filed for three vacancies. Don Carter, Sam Tiner and Bob Hefner were elected to the council. The *Dallas Morning News* reported the professions of the three: "Carter lists himself as a Coppell businessman. Tiner is in the real estate business and Hefner manages a lumber yard in Addison."

Carter, Hefner and Tiner ran as a ticket, and their election to the five-member council created a majority voting block. Hefner said that both he and Tiner were actually employed by Carter during the 1972 to 1973 timeframe. Although they didn't always agree on issues, they had the votes among them to be the legislative and approval power on the council. They had their own agenda for Coppell's water and sewer, he said.

"During our term we ran the first waterline down Sandy Lake Road off of city water," Hefner said. "And that was part of our master plan when we went in, I mean, on our agenda that it had to be done."

The development of water and sewer service continued to be a slow process. In lieu of waiting on the city, a group of landowners, including Councilman Don Carter decided to take a different approach. In May 1974, they petitioned the state to create a municipal utility district.

The district was originally conceived as containing 3,120 acres of Coppell land. The main function of the Coppell MUD was to provide water, waste water services and drainage facilities within its boundaries. If approved, the district would collect its own taxes, charge for services, condemn property, operate and make regulations to accomplish its purposes. The state evaluated the petition, held a public hearing and granted the petition. Five temporary members were appointed to the MUD's board of directors, until an election could be called to elect permanent board members, to confirm the MUD's creation and to authorize bonds and taxing authority for bond repayment.

Coppell voters blessed the MUD concept on June 8, 1974. Its first directors were Horace Vail, Morris Ethridge, June Freeman, Jesse Franklin Jr. and Clarence Cornutt. The First Bank of Coppell was named depository for the new district.

"I was against the MUD," said Hulen Scott, mayor of Coppell at the time. "We were headed that direction already with the HUD grant. They came up with the MUD after we already had an application in place for a grant with TRA to put sewer in right. But, the grant was taking too long. People were saying they wanted sewer."

"There was no way the city could do water and sewer," Hefner said. "Well, we might have gotten water for most of that area, but we could never have gotten sewer. And, so we had to put everything through the MUD district because that was just the only way to get it out there. Hulen didn't vote except in a tie. And, we had a three-vote block, so there was seldom a tie."

"The council approved it," said Scott. "Those that supported the MUD said, 'Ah, we want the advantage of these landowners.' In my opinion, they only wanted to control the design and where it went."

"Well, the MUD expedited construction," said Scott. "Dirt was turning in '75 and they were tying people on it in '76. I tied on to it myself. There was an extra tax for new people, but we did get a clause in the agreement where the existing people didn't have to pay the MUD tax, me included. That's how those people got water and sewer. If I had it to do over, I'd try to do something to find a way to prevent the MUD district from happening. It was created from outside influence. We had our own program already in place. It would have taken about another year by law."

Coppell eventually built a fire station, jail and city hall in old downtown.

The creation of the Coppell Municipal Utility District in 1974 was significant to Coppell's history. It provided water and sewer infrastructure to Sandy Lake Road residents and, thereby, finally put an end to the litigious period involving city services. The MUD also opened the town for residential growth. Within months of such infrastructure improvement, developers purchased residential land to begin subdivisions. And, the resultant population growth balanced the political process and neutralized the two political factions. Thus, Coppell began to work as a total community in contrast to geographical politics. Ironically, the Coppell MUD was similar to the same utility district Joe Driscoll had proposed eight years earlier.

The city eventually took over the MUD in 1994. To achieve this, Coppell absorbed the district's debt, caused by the development and maintenance of a separate water and sewer infrastructure in northern Coppell. The district's twenty-year existence as a separate taxing entity within the city of Coppell came to an end. Signifying the growth it created, the district, at the time of takeover by the city, was providing 70 percent of Coppell homes with sewer service.

D/FW AIRPORT CREATES COPPELL LAND RUSH

The Civil Aeronautics Board ruled in 1964 that Dallas's Love Field and Fort Worth's Great Southwest International were not suitable for future aviation needs. It ordered the two cities to find a site for a joint airport within six months, or it would do the job for them. A site situated seventeen miles from both cities was found.

Thus, for the second time in ten years, two of the largest economic development announcements affecting North Texas had both been proposed at Coppell, the 1,750-acre, $70 million North Lake Generating Plant & Recreational Park announced in 1955, and, in 1964, the new 17,000-acre Dallas/Fort Worth Regional Airport.

The *Dallas Morning News* reported the developing story in the fall of 1965: "A Dallas County town in which excitement went sky high after the site for the airport was announced was tiny Coppell, a community of 1,200. Land has risen sharply in value, according to Coppell Mayor W.T. Cozby. Cozby said the airport would make the town's sewer and water bonds, which have been contested, more feasible…Mayor Cozby, owner of Coppell's only real estate business, predicted industrial growth as a result of the town's proximity to the proposed airport."

However, local residents had mixed feelings about how the big airport would impact them. Clyde Sanders, seventy-five years old at the time, had a farm on the west side of Coppell, right at the county line. His house was in Tarrant County, and his barn was in Dallas County. A *Morning News* article asserted that the airport "will probably gobble up his 20 acres."

"I'd hate awful bad to leave this place," Sanders told the paper, "but if they have to have it, I guess they'll just take it."

Another *News* article described some concerns about the adverse impact of having the airport so close. "Coppell Mayor Cozby, born in 1908 on a farm in Denton County and reared in Coppell, said, 'The airport will be advantageous to the growth, although some seem to believe it would be detrimental to the town. They're afraid of the noise problem. But we won't be in any flight pattern and we will be close enough in that we won't be bothered by any circling traffic.'"

"'Lots of people have been out looking for land,' he [Cozby] added. 'But they don't know what to do, whether to hold it or sell it or what.' He figures the fair market value of most of the land in the area to be not more than $1,500 an acre.…'When we can furnish water and sewer lines, we will collect additional taxes. Some people think we will get quite a bit of industry since we're as close to the airport as we are.'"

In 1967, another announcement by the Dallas/Fort Worth Regional Transportation Authority caused Coppell-area land to continue its rise in value. A $32.5 million extension of LBJ Freeway from Forest Lane and Stemmons westward to the new regional airport was proposed and quickly adopted. North Lake Power Plant, D/FW Airport, LBJ Freeway extension—it appeared that everything was going to or by Coppell.

By 1969, Coppell's land boom was evident, not only from the direct purchase of an expansive amount of land for the airport but also from speculators who wanted to profit by being around the big airport. Airport development occurred on a sprawling scale. Buyers acquired 27.5 square miles of farmland for the project. The *News* affirmed the land rush: "The great land boom is invading northwestern Dallas County and the town of Coppell where land is selling for as much as $7,500 an acre and as little as $1,600 an acre, depending on its proximity to Dallas-Fort Worth Regional Airport, Mayor W.T. Cozby said at the small frame building that serves as a city hall. 'We are at the northeastern perimeter of the big airfield,' said Cozby. 'It looks like they will take about 1½ square miles out of our town site, but we don't know whether the airport site is going north of Bethel School Road. If the site buyers go there, they may take as much as 2 square miles of territory.'"

"Mayor Cozby said there is 'an awful lot of talk about apartments,' and two mobile home parks are already underway, one a 20-acre 200-unit park being built on Coppell Road by J.D. Brown of Dallas and another a 9-acre, 75-unit court planned by Gaston and Zetley, also of Big D."

Two additional land speculators had purchased land within Coppell at the time, anticipating completion of the regional airport. S.E. DeRoulac of Alamo in Hildago County bought 80 acres, and Dallas attorney Roger Sullivan purchased 66 acres inside the city limits. Prior to the airport's land rush, the area's largest landowners were Dallas Power & Light Company with its 1,750-acre North Lake Generating Plant and the Baptist Foundation's 300 acre-tract around Grapevine Springs Park. The airport's presence created land flips and volatile prices.

"After the airport came in you started having all this land changing hands," said Coppell resident Richard Lee. "All kinds of developers were wanting to come in."

In most cases, speculators just wanted the land. So, a few houses were moved from airport property. Some were moved to Coppell. "The airport just come in and bought what they wanted," said Bobby Ottinger. "And, most people [were] wanting to sell because there was no market for the land at that time unless you wanted to farm. The house that I live in was built on airport property. In '73 I bought it and moved it where it is now. It came off the property on the west side of Coppell, just south of Bethel Road."

By 1973, D/FW Airport had grown into a city within itself, even having its own zip code, 75261. When opened, it was the largest and costliest airport in the world. More than $700 million had been spent developing its 17,500 acres. The first landing of a supersonic Concorde in the United States occurred at D/FW Airport in 1973 to commemorate the airport's completion. The first commercial flight landed at the airport on January 13, 1974.

Today, the airport staff reports that the facility operates like a city, covering more than 29.8 square miles or 18,076 acres. It is the second-largest airport in the United States in terms of land mass and third largest in the world in terms of operations. More than 27,000 employees fill airport facilities each workday. In terms of aircraft movements, it is the third-busiest airport in the world. In terms of passenger traffic, it is the sixth-busiest airport in the world, transporting 59,064,360 passengers in 2005. The airport generates $14.3 billion each year for the North Texas economy, and its impact is estimated to support 268,500 jobs. Flight operations serve 129 domestic destinations and 36 international cities. It is the largest and main

Above: Coppell patterned its first logo after the circular concourse design of D/FW International Airport itself.

Right: Establishment of First Coppell Bank on South Belt Line at East Belt Line Road was a sign of growth to come.

hub for American Airlines, with 800 daily departures. Some 84 percent of all flights at the airport are operated by American Airlines.

Although there have been overflight pattern and noise issues between the city and the airport through the years, the fledgling community of Coppell benefited from the location of D/FW Airport at its southwestern city limit. Coppell real estate increased dramatically in value. Growth came. Tax revenue followed. City facilities were funded. Acknowledging this windfall, the young city patterned its first logo after the circular concourse design of the airport itself. Just eighteen years prior, Coppell had been a small, rural, unincorporated area. In 1974, D/FW Airport gave Coppell access to the world.

A Major Fire Burns in Old Town

"After the airport came in, then you started having all this land changing hands," Fire chief Richard Lee said. "All kinds of developers were wanting to come in. Well, C.L. Plumlee and his family lived in a house up on top of that hill going out West Bethel Road. It was across the road from the airport property. And they sold their property. The buyer told them they could have the house if they would move it off 'cause they didn't want it. What they

155

wanted was the land. So, they got the idea of moving that house from up there on the hill down to the lot in town. That house was about as big as the lot was 'cause it was one of those big Victorian one-and-a-half story houses with gables and all that. It had a porch all the way around it."

"And the city tried to keep 'em from doing that," Lee said. "They told them 'no' to start with. It got into all the papers. The *Dallas Times Herald* was really big into it. They wrote that the city wouldn't let a longtime family move an old family house downtown and all that kind of stuff. There was a lot of conflict, quite a bit of conflict. And, there was a big controversy about it. It went on for probably two or three months; then, the city decided, 'Let 'em move it. We don't want to sit and fight here.'"

"So, they were going to move it," Lee said. "If I remember right, it was on a Friday. It was hot and dry. They picked it up, put it on the rail and went south to the railroad, came down the railroad there where Home Interiors' old building is now and were coming up Coppell Road. There just wasn't enough room when they were moving over so that they could turn into the lot. They got it right under those power lines. And they were the main transmission lines to the town. They got into 'em. They knocked the power out all of town."

"What they had done, the lightning rods, instead of taking them all the way down, they just laid 'em straight out. They got into those power lines there, and it was just like lightning hit it. There was a kid riding on the porch of the house, and he said balls of fire were rolling around the ceilings and the floors and it shorted out when it hit the ground. Electricity just went all through it. Those lightning rods led underneath the little rails and the truck's old tires that were worn out, they shorted out. The kid bailed off of it," said Lee.

"Randy Corbin was working at the fire department then," Lee said. "By the time he came around the corner with the first fire truck, it was pretty much engulfed in flames, I came as quick as I could. My word, it looked as if somebody had thrown a can of gas on that truck and on that house. In a situation like that, fire is everywhere. Mike Rainey had pulled up with the little Ford pumper and hooked up to the fire plug. Well, he had enough water to charge a line. Randy and some of 'em had already emptied the truck that we had there. When Mike Rainey hooked up to that plug, he pulled a vacuum."

"What had happened, they had knocked all the electricity out all over town." Lee continued. "There was no pump station. There was no water. About then we started getting mutual aid in. Irving came in, Carrollton,

Grapevine and Lewisville came in. All the water we had was what other fire trucks were bringing in. It was bad. They started protecting the houses around it 'cause we would've lost three, maybe four houses."

"It went in a hurry. The house was up off of the road about three foot, so once it started burning, it went in a hurry, just like a chimney. If they'd of made it up to Bethel Road, they'd of been right downtown."

"It was a sad thing," said eighty-year resident Zelma Plumlee. "C.L. and Iska Plumlee had paid Dallas Power & Light Company to have the power turned off. She had over $18,000 worth of antique furniture in that house, and in those days that was a considerable amount of money. Also, all their important papers were in there. You see, in those days, you moved a house with everything in it."

The Plumlee house fire is one that most of the early volunteer firefighters remember. The lengthy political controversy about obtaining a city permit; the publicity carried by the Dallas, Lewisville and Grapevine newspapers; the "downtown" location of the destination; the towering inferno in the middle of a city street; the electrical fireworks caused by the arc of electricity; and the resultant power outage affecting the city's water pump station—all combined to create a calamity of fire in old town.

Rooftops Come

In 1974, Coppell encompassed approximately 7,500 acres of land and hosted a population of about 2,500. The city had three full-time policemen with two radio-equipped vehicles. The fire department had 3 paid firemen, 22 volunteers, 14 registered EMTs, 3 fire trucks, one heavy-duty rescue truck and one ambulance. Coppell Independent School District contained two schools, an elementary-middle school and a high school. There were 533 pupils in the district.

After years of disappointment, land speculation, legal challenges and political infighting, Coppell appeared ready to grow, according to a *News* article quoting Dick Thomas, president of First Bank of Coppell: "The creation of a Municipal Utility District, approved by the Texas Water Control Board and voted in by residents of the area, will make the development of Coppell a more immediate reality. Every industry and residential developer considers the immediate availability of utilities in his planning, and we will soon be able to offer the same development sites that

other Dallas County communities can offer, plus our proximity to the Dallas-Fort Worth Regional Airport."

One month later, Dallas developer Bill Troth announced an $8.5 million residential subdivision in eastern Coppell. "We have found a really beautiful piece of property only five minutes from the new Dallas/Fort Worth Regional Airport, but out of the flight pattern where the residents will find a peaceful setting only 18 minutes from downtown Dallas," Troth told the *Southwest Business Scene*.

An experienced land developer, Troth was best known at the time for his development of Richardson Heights in Richardson, Northwood Hills and Northwood Hills Estates in far North Dallas and Meadowcreek in Garland.

Bill Troth's standing in the building community and commitment brought residential growth to Coppell.

Coppell councilman Don Carter contacted Troth about developing land Carter owned in Coppell. Troth's reputation and commitment to residential development would significantly impact Coppell's growth. In 1974, Troth bought approximately one hundred acres for the first phase of development.

"We bought the land from Don Carter," said Troth's daughter and business partner Judy Troth Parsons. "We had been looking at another piece of land on Greenville Avenue in Dallas. The Coppell land had a lot more potential so our whole family decided to invest in its future. All of us became involved in the development process."

Called Northlake Woodlands, the new Coppell subdivision utilized one-third- to one-acre lots for homes priced from $40,000 to $130,000. All utilities were underground in the country-style subdivision. Phase One of the development platted 170 homes on ninety-five acres. The average price of the houses was approximately $50,000.

Taxes for the city at the time were $0.95 per $100 based on only 30 percent of assessed value. School taxes were $1 per $100 based on only 50 percent of assessed value. Thus, a $50,000 home would pay a total city and school tax of less than $400.

Coppell's Northlake Woodlands' first phase of development capitalized on the natural beauty of wooded land between Belt Line road and Moore Road on Bethel Road, said Parsons. The first streets developed were Meadowcreek, LeeValley, Rocky Branch and Rolling Hills. Houses were first constructed on Rocky Branch. They were three- and four-bedroom homes comprising 1,900 to 2,400 square feet.

In 1975, Coppell city councilman Hazel Beal announced to the *Dallas Morning News* the creation of a commission to market Coppell. Its goal was "to interest developers, realtors, and corporation officials in the northwest Dallas County city…One of the first projects of the commission's agenda is a tour of the area for interested parties." As a result of marketing efforts, a few homebuilders and realtors came to see Coppell. And some private individuals bought lots. Soon builders began to construct custom homes on a contract basis. Their names are part of the city's real estate history. Dallas home builder Lee Schiefelbein and Pat Patterson both began houses in the subdivision in 1976. They were joined by Danfor Homes, Brand Popkin, Meadows Building Company, Urban Image, L.C. Smith, Pardue and Sons, Sublime Homes, Chism Properties, Ambassador Construction Company, G and W Custom Homes and Franklin Watkins.

"We were on the leading edge of residential development for Coppell," Parsons said. "It was hard to get builders to come to Coppell. Basically the town's identity was the Dairy Queen. I remember riding my horse through Northlake Woodlands to the Dairy Queen. We had no grocery stores or retail to speak of. When you went grocery shopping you had to drive five to ten miles. So, you made a list and shopped for a week. When I would write a check for groceries, cashiers would look at my check and ask where Coppell was."

"In April 1976, we moved into a house on Rocky Branch," Parsons said. "We were the first people to move into Northlake Woodlands. Two other houses were completed, but Schiefelbein hadn't sold them yet. Everything went slow at first. Then house sales began to pick up in 1977."

"We started Dorsey Homes in 1977 and began to build contract jobs for people needing a builder for their lot," said Mike Dorn, founder of Dorsey Homes. "Nobody knew where Coppell was. I met realtors in Irving who had been selling real estate for twenty years and they didn't even know where Coppell was."

By the end of 1977, fifty homes had been completed in Northlake Woodlands. About that time, Roy Brock's Carmen Homes, Louis Crump Homes, Rick Church, Frank Bamburg, Widner Properties, Inc., Charles

Troth Custom Homes, Troth Enterprises, Richard C. Troth, Inc., Four Seasons Custom Homes and Sullivan Custom Homes entered the Coppell homebuilding market. These builders constructed hundreds of custom houses in Northlake Woodlands.

"Northlake Woodlands was good for us," Dorn said. "For a number of years, it was the only development here."

Slowly, Coppell's "country lifestyle" got discovered, and the town became a residential destination for prospective home buyers. Years later, other land developers and builders followed Troth. In the late '70s, Fox and Jacobs announced its Willowood subdivision in Coppell, just east of Heartz Road and north of Bethel Road. Within just a few years, hundreds of F&J homes were built.

Eventually, more developers came to town and more subdivisions were built, but Troth spearheaded the residential growth for Coppell with large wooded lots, custom-built houses, underground utilities, meandering residential roads, small-town living and a good place to raise a family.

During subsequent phases of Northlake Woodlands, Troth developed even more residential land. When complete, Northlake Woodlands covered much of the land mass bounded by Denton Tap Road on the west, MacArthur Road on the east, Sandy Lake on the north and Belt Line Road on the south. According to the City Engineering Department, Troth's development involved twenty-six phases and 557 acres of land and produced more than one thousand custom home lots. He died in 1998. His contribution represents 13.8 percent of all residential constructed in the city during twenty-five years.

IH-635 EXTENSION PROVIDES ADDITIONAL GROWTH STIMULUS

Coppell's growth was further enhanced by another announcement in 1974. The City of Dallas revealed plans for extension of the western portion of Dallas's outer loop, I-635, from I-35 west to the north entrance of D/FW International Airport. The proposed highway would pass along Coppell's southern border and give residents interstate access to the rest of Dallas County. It opened for traffic in 1980.

The Dairy Queen
Was Coppell's Identity for Years

In the late '70s, Coppell had few businesses. Business names and managers from that time come to mind, including Wanda's Café, Herrington's Bait Shop, JenCo Nursery, Stop-n-Go, Layton Realty, North Lake Nursery, the daycare run by June Chenault, Bob Chastine's filling station and auto shop, the old town barbershop, *Coppell Star* newspaper, First Bank of Coppell, Hitchcock Movers, Lucille Young Realty, Coppell Grocery, Coppell Veterinary Hospital and Café 121. Yet it is the Dairy Queen that everyone remembers.

"The original owners were the Doziers," said Dairy Queen owner Parrish Chapman in 2006. "In 1976, Coppell was growing. This area was dramatically growing. And, so, Coppell was picked for that reason. I think that it was just a good pick for the future."

Vonita and M.L. White moved to Coppell in 1971. She started teaching school at Coppell Elementary that fall. "Everybody was excited when the Dairy Queen first came in," said Vonita. "We finally had a place to eat. We would go down to the Dairy Queen from Coppell Elementary [now Pinkerton Elementary] and get lunches for the teachers. Sometimes we would just order a hamburger. It was very exciting. We really had arrived!"

"The Dairy Queen was our golden cow," said retired First Assembly of God pastor C.A. McBride. "It's been there a long time. You know, they had to tear Mayor Cozby's real estate office down to build it. It was right on that corner, little bitty."

"In the middle of this country setting there was a Dairy Queen," said Evelyn Elwood. "We liked their ice cream and sometimes would go to get a burger. They were close and convenient for us. For a long time, it probably was our town's identity. I would usually tell people how to get to our house from the Dairy Queen."

"A lot of people still tell me that the Dairy Queen is kind of a directional icon of Coppell," Chapman said. "You know, 'Go to the Dairy Queen, turn left' or they say 'Come up to the Dairy Queen, you're in the right neighborhood.' And, so, we're the direction headquarters for this part of the world. You go into the Dairy Queen during lunchtime, people have maps out. 'Beltline is this way. Beltline is that way.' 'We're lost.' Also, 'We're going to the airport. Where's the airport?' So, we're kind of the direction headquarters of Coppell. Our Dairy Queen is a goodwill ambassador as I look at it."

"I remember going to the Dairy Queen before we moved here," said Margaret Bryan. "It was the only place here. You always used it to help someone find Coppell."

"I think it's still the identity of Coppell," Chapman said. "I was flying to a Dairy Queen meeting, and this lady was sitting beside me. She asked me about my business and I told her I was in the Dairy Queen business. She said: 'Oh, we have the best Dairy Queen.' I was like 'Oh, really?' because sometimes when you say you're in the Dairy Queen business you get beat up for three hours. So, I said, 'Oh, that's great. What town do you live in?' She said 'Coppell.'"

"I first started going to the Dairy Queen when it first opened," said Zelma Plumlee, at age ninety. "It had good burgers and still does. That was our main place to go."

"Anne and I moved to Coppell in 1981," said Coppell resident and retired CISD principal Bruce MacDonald. "We went to the Dairy Queen to sign our house papers."

"The Dairy Queen is kind of the anchor of the community," Chapman said. "We're the meeting place. We have realtors writing contracts. We have State Farm agents meeting people and typing up insurance. We often see somebody that works at IBM or somebody that works in the other part of town meeting here to have lunch. There's business being done at DQ. I think it's kind of really a nice place to come in and visit."

CITY STAFF GROWS

There are always firsts—first law enforcement officer, first librarian, first city administrator. As the city grew, Coppell began to add city staff. "The first city administrator was Sam Little," said Hulen Scott, mayor of Coppell from 1971 to 1977. "He only served a couple of months, probably about four months. He came to Coppell sometime around the first of the year in 1972. He left in April or May."

"After Sam Little, George Campbell became city administrator," Scott said. "I contacted Texas Power & Light, because in those days they knew people in different cities, and they told us that Campbell might be somebody we wanted to talk to. So, we got his name from Texas Power & Light."

Campbell served the community from 1972 to 1977.

POLICE FORCE STARTS SMALL

"Our first patrolman was Kelly Story," Scott said. "He was a bricklayer. He laid brick in the daytime and patrolled at night for three or four hours 'til all the bad people went to sleep, you know, by nine o' clock. However, when we set up the police department, he decided there was a lot more money in laying brick than there was in part-time police work."

Story's brick-laying skill and police interest were put to work on behalf of Coppell. The *Dallas Morning News* reported in 1967 that Coppell citizens,

with the support of city government, completed a "Do-It-Yourself" building. Built by approximately fifty citizens, a DIY jail was completed after two years of work. The building housed an office and two small jail cells. The *News* reported that Story, a brick mason and part-time police chief, "considered the building just part of his duties."

"So, the first full-time police chief, I guess, was Tom Griffin," Scott said. "Tom Griffin lived here in the city. He was a resident of Coppell and attended the First Baptist Church. He was originally from Oklahoma."

"Tom was a character," former councilman Bob Hefner said. "You know, when we hired him, he was a full-time National Guardsman. But, he had an interest in police work and we didn't have a police chief. You wouldn't believe some of the résumés we got in, a captain from Garland, a lieutenant from Irving. There ain't nothing wrong with these people, but six months later most of 'em would go back to the very department they came out of and they'd go back as captain or major once they had chief on that résumé. We got tired of the revolving door. Tom expressed interest in it, and we appointed him right out of the National Guard."

"We had a policeman, Don Swearingen, that got killed doing patrol," Scott said. "It was on Denton Tap Road, down there at Grapevine Creek. You know that dip there; he went over that dip. There was some talk he was in pursuit of another car and lost control. His police car was on the west side of the road. He was going northbound. So, he left the road on the left side, going north. It killed him instantly. Tom Griffin was police chief then, and Don was probably one of his first officers."

CITY ATTORNEY CHANGED BOUNDARIES

"One of the things that the power company used to do for little towns is they furnished the legal counsel," said Scott. "They did it for Coppell for several years. They picked up the tab. Larry Jackson used to get his money from Texas Power & Light. They don't do that anymore."

Jackson's involvement with Coppell had far-reaching effects. Years later, his research during several court cases eventually led to a change to the Denton-Dallas County line in north Coppell.

"The exact boundary of the Dallas-Denton County line was never a set line," Jackson said. "There were two boundary lines. One was south of the other. And they didn't know really which line was the true Dallas-Denton

County line. Thus, there were two county borders. And the taxing districts in this area made up agreements that certain portions would be taxed in Denton County, while certain portions would be taxed in Dallas County. At one time, I did write some letters to the county commissioners saying that line needed to be straightened out."

"When I was trying to figure out the correct county line," Jackson said,

I went down to the old red courthouse and searched through the records. And then, they even sent me down into the lower portions of the various courthouses. In the basement, I crawled under big pipes and stuff looking for some of this information. At one time, I did find some surveyor's notes. Those notes explained a point where one surveyor came across the creek, was attacked by a band of Indians, made a retreat south down the creek and later, after they were safe, came back across with their survey line, but didn't go back to where they were originally attacked. And that was the reason why one of the surveyors' notes showed a jog in the Dallas-Denton County line. The Dallas-Denton County line actually came off this one major survey of Dallas County. And all of the various county surveys around Dallas then came off of this same Dallas County survey. So, all were incorrect.

Jackson's significant find, legal research and arguments led to a formal revision of the official Dallas-Denton County line. The jog at the creek, caused by the Indian raid, was taken out. Thus, the line that ran through Coppell was moved to the north, bringing more of the city's tax base into Dallas County.

City Secretary Joins Staff

"Our first paid city secretary was Dorothy Timmons," said Scott. "She was a great person. She came in late '72. She was from Tulia, which is out there in the general area of Lubbock. If my memory serves me right, it seems like Campbell knew her from the Lubbock area. He's the one that brought her in."

"In '72, city hall was in a little brick building in back of the water tower," Scott said. "It used to be the jail, built with one or two cells. That was the whole works, city hall and all. The city council met in there. Later we had a

metal storage building situated in the back of the old fire station. And that was used as a city hall up until the time they built Town Center (in 1986). We met in there for probably three years. Then, in '76 we met for a while in the bank building. Sometimes some were saying we needed more space. So, we started meeting at the school. They let us meet in the elementary cafeteria. Then the little brick jail building became the water department."

City Adds Water Department

"Coppell had a water system," Scott said. "It was small, but served several people. Fay Rush worked water billing part time. She worked three days a week. That was the office staff, just her."

"[Arthur] VanBebber did contract work for the city to keep the water system operating," Scott said. "He also monitored the pump station and sewer quality. In other words, he was our first water and sewer guy. He was an old timer around here, primarily in business for himself, but he contracted ad hoc with the city. The city at that time did not have a salaried employee as such. All we had was part-time or contract work."

"Jick was the name by which we knew him," said Zelma Plumlee. "He took care of the city's water, then sewer. He was a good man. Even when he had cancer, he would go out in the weather to fix broken pipes."

Coppell Establishes Public Library

For most of his adult life, former Coppell city councilman Bob Hefner had collected books. Reading was his passion, so acquiring books came naturally to him. Many had been obtained from garage sales, Canton's "First Monday" vendors and various library liquidations. He kept hundreds in his home and hundreds more in storage.

So, Hefner sought to establish a library. He focused his goal around one belief: "Every town needs one. Every town uses one. Coppell must have one."

"After one term on the council, there was only one other thing that I wanted to do that we hadn't done and that was to create a library," Hefner said. "So, I thought I could do better as mayor than I could as councilman. I ran against Hulen Scott. He beat me by seventy-two votes."

"When I didn't get elected mayor, I still wanted the library," Hefner said. "So, I rented [an] old house in Coppell to have a library. I had a personal library of seven thousand books. I took my seven thousand books and gave them to the City."

That is how an old frame home, situated at 561 North Coppell Road in old downtown, became the Coppell Public Library. The house, built in the late 1890s, was originally the W.J. Russell residence and later owned by the Parr, Corbin and Nesbitt families. The building, with less than one thousand square feet, began operation as a library in 1974 with three thousand books from Hefner's private collection.

"I spent a lifetime collecting 'em," Hefner said. "I've always been and still am basically a nonfiction reader. I like history, biographies, historical novels and the like. I had outgrown my space in my house. My library books were two deep on the shelf. I couldn't see half of 'em. I doubt if there was fifty paperbacks in the group."

"Jo Jackson was our first librarian," Hefner said. "The library took hold and grew because of Jo and her input. She was a fine, little lady. I can't tell you if Jo was short for Josephine. She was disabled; walked with a walker. She made that library."

"Jo did the inventory on 'em," Hefner said. "Of course, she catalogued 'em before it was all over according to Dewey. They weren't the current best sellers. They were all the classics of my years. I had bought them at different libraries."

Some residents remember Jackson as the "Bird Lady" of Coppell, emphasizing her passion for birds. On Tuesday mornings at the library, she always had a lecture or story time for local children. On one such morning, she spoke on "Birds of the Coppell Area." Her visual aids comprised stuffed birds of various species, which the children could handle during the lecture.

Jackson first acted as librarian in name only, as a salary was not available. "It's true," Hefner said, "most of the money that went into the library in those early days was my money, but it might not have lasted sixty days without Jo."

Like Jackson, volunteers initially staffed the library and served on the first library board. Assistant librarian was Cindra Morgan. Library board members were Bob Hefner, chairman; Evelyn Ottinger, secretary; Verlie Brinson, treasurer; Dick Thomas, finance; Bill Vinson, maintenance; Charles Checkley; and Doris Gilchrist.

Being a volunteer on the library board in those days meant that you mentored every aspect of the operation, including maintenance. In the summer of 1979, members of the board were joined by a few friends as

they painted the exterior of the building. With the use of a borrowed paint sprayer, twelve gallons of paint were applied in four hours to complete the job.

Also, by 1979, both Jackson as librarian and the library, as state accredited, were officially on the city budget. Such official status created additional community interest in the library. Walter Pettijohn became chairman of the library board. Barbara Lee, Dorothy Jackson and Ruby Nell Wilson were appointed, and Theresa Eby joined the board in her capacity as chairman of a new ten-member support group called "Friends of the Library."

"We would like to see each person in Coppell get acquainted with our library, personally," Jackson said at the time. "We really do have something for everyone and want all to take advantage of our services."

Citizens responded. The library began to grow. Inventory at the time was 8,879 books. However, the little frame house was beginning to show the strain. The building, more than eighty years old at the time, was requiring special care to endure the weight of so many books. "We are in good shape right now, but we want to grow with the city and our building, we hope, will serve us a few years longer," a board member said at the time.

When Jackson resigned in the fall of 1979, the library's hours of operation were reduced to only twelve per week. The library, nursed by the community for five years, was in jeopardy. However, the city responded in support. In 1980, Judi Biggerstaff was hired as full-time librarian. She had a degree in library science and English from Clarion State University in Pennsylvania and had recently moved to Coppell.

The building held more than 10,000 volumes, 1,500 paperback books and 22 magazine subscriptions. Library staff in those days often fought the elements just to keep books on the shelves of the aging structure. In winter, the staff often wore coats to stay warm inside the old building. Antifreeze was poured into the commode to keep it from freezing. And, when a pipe froze and burst in the bathroom, they chopped ice off the floor. However, the library stayed open and the facility continued to grow. Of Coppell's 3,801 citizens, by the 1980 census, 1,200 had library cards. Still, it was just a matter of time before something would have to be done.

In 1984, Coppell citizens approved a bond issue that would fund a new library as a part of a new city hall. In December 1986, the library facility opened as the William T. Cozby Public Library. More than three hundred names had been nominated for the honor. Mary Evelyn Mobley, Cozby's

sister, campaigned to have the new facility named after her brother, the former mayor with a twelve-year tenure. Numerous senior citizens were present when the decision was announced and broke into applause.

"I can think of no one more deserving than Bill Cozby," said former city councilman Wheelice Wilson Sr., who served with Cozby. "He did an awful lot to make it [the town] what it is today."

With 5,890 square feet of new space, the library quickly expanded. Under Biggerstaff's direction, the staff grew to six employees. New technology was added. Circulation of library materials tripled, increasing to 40,780 in 1986. The staff was increased to ten. By 1989, library circulation had increased to 118,871 items.

The doors opened at the present freestanding library on April 24, 1995, and a major renovation was completed in April 2005. Today, the collection at the library contains more than 110,000 books, CDs, videos, DVDs, audio cassettes and internet workstations. In addition to these items, the library subscribes to more than 170 periodicals and newspapers. By 2014, the library was circulating 453,000 items per year and served a population of more than thirty-nine thousand residents. Renovations began again on the library in 2015.

City Adopts Motto

What began as a small rural settlement with farming as an economic base became a thriving, growing community, with a dynamic residential foundation. Soon, it would become a hub of business and corporate development. Its motto was "A City with a Beautiful Future."

COPPELL TIMELINE

1500 BC Native American tribes begin camping near Grapevine Springs.

1843 Sam Houston, president of the Republic of Texas, camps at Grapevine Springs with the intention of negotiating one of many treaties with Indians.

1848 James Parrish receives a 640-acre land grant and builds a home on Moore Road; the surrounding community, called Bethel, has a Baptist church, school and cemetery.

1874 W.O. Harrison establishes the first general store.

1879 Grapevine Springs Chapel Methodist Church is established, serving as both church and school.

1887 Post office is housed in Harrison's General Store.

1888 Railroad opens with several stops daily; area is named Gibbs for Barnett Gibbs, eventually the lieutenant governor of Texas.

1890 Railroad opens new depot and changes the name of post office and town to Coppell, after George Coppell, prominent railroad executive.

1893 Coppell has four stores, a school, a lumberyard, a blacksmith shop and a cotton gin.

1909 First State Bank of Coppell opens, and the town newspaper is the *Coppell Informer.*

1911 Second school building is built next to original in downtown.

1914 Coppell has two churches, two general stores, two blacksmith shops, a bank, a hardware store, telephone service, a population of 450 and a trade of poultry, livestock and lumber.

1926 Population decreases to two hundred for a decade.

1936 WPA establishes Grapevine Springs as a public park.

1955 Coppell is incorporated.

1956 R.M. Johnson is elected as first mayor.

1958 Coppell's first volunteer fire department is created.

1959 Coppell school becomes an independent school district.

1964 North Lake Generating Plant & Recreational Park opens on 1,750 acres southeast of Coppell.

1970 Coppell has a population of 1,728 and eight businesses.

1974 Dallas/Fort Worth International Airport opens adjacent to Coppell.

1979 Coppell Public Library is formally established.

1980 Extension of I-635 from I-35 to D/FW Airport opens along Coppell's southern border.

2000 Ongoing development and growth increase population to almost forty thousand.

Coppell's Mayors

In 1955, thirty-four signatures were filed with a Dallas County judge to call an election for the incorporation of Coppell as a town. On December 17, 1955, forty-two ballots were cast in that election. Incorporation passed by a 41–1 vote. On January 19, 1956, Coppell held its first council meeting in the schoolhouse.

The following have held the office of mayor for the the city of Coppell, Texas:

R.M. Johnson: 1956–60
W.T. Cozby: 1960–70
Hulen Scott: 1971–77
John R. Burns Jr.: 1977–79
Andrew Brown Jr.: 1979–85
Lou Duggan: 1985–89
Mark Wolfe: 1989–93
Tom Morton: 1993–97
Candy Sheehan: 1997–2003
Doug Stover: 2003–09
Jayne Peters: 2009–10
Doug Stover: 2010–12
Karen Hunt: 2012–present

ACKNOWLEDGEMENTS

We have attempted to bring Coppell's history to you in an honest and straightforward chronicle. And we have striven to make it as accurate as possible. As with any historical project, our efforts were largely dependent on the knowledge of those who lived it, those who recorded it and those who preserved it.

Coppell, Texas: A History has been a work compiled for more than thirty years from many sources and numerous writers. As such we would like to acknowledge those who helped make this effort possible.

Helpful and acknowledged frequently were the archives of the *Dallas Morning News*, the *Lewisville Leader*, the *Fort Worth Star Telegram*, the *Dallas Times Herald*, the *Carrollton Leader*, the *Grapevine Sun*, the *Citizens' Advocate* and the *Elm Fork Echoes*. Each of these publications captured at some period events of Coppell's history for the general public.

Additionally, many local citizens contributed their notes and writings about Coppell's early days. Our special thanks to each of them.

Our research found a voluminous history, more than space allowed us to print in this book. We were unable to incorporate hundreds of photos and thousands of words from our original manuscript. However, the specific events captured herein crafted the community Coppell had become in the late 1970s. They are recorded here for us to reflect, to understand and to provide the basis for a future narrative about more political turmoil and growing pains to come in the 1980s.

Jean Murph and Lou Duggan

ABOUT THE AUTHORS

Jean Murph first wrote for the *Coppell Star* before creating the *Citizens' Advocate* in Coppell in 1984, an independently owned community newspaper. She is an active member of the Coppell Historical Society and lives with her family in nearby Grapevine, Texas.

Lou Duggan was elected to the Coppell City Council in 1983 and served as the city's sixth mayor from 1985 to 1989. He joined Jean Murph at the *Citizens' Advocate* newspaper in 1990 as associate publisher/editor until 2010.

During the intervening twenty years, he and Murph authored hundreds of articles, columns and feature stories about Coppell, many of which focused on the city's history. Duggan and his wife, Judy, remain active within the community.